IMAGES
of America

WILBRAHAM

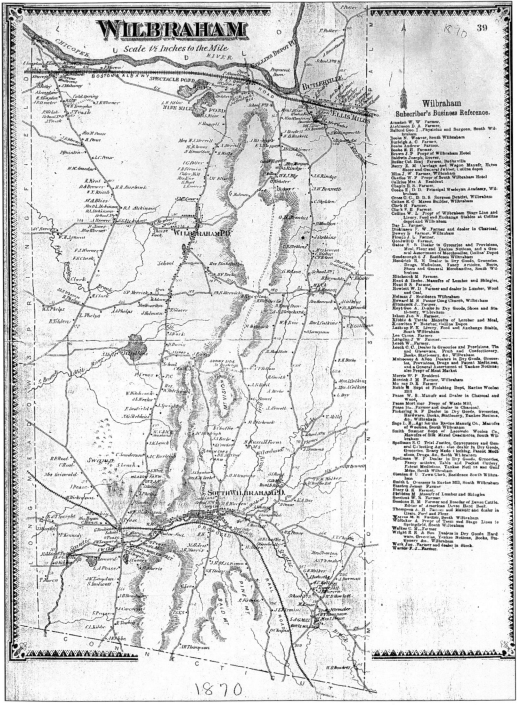

This map shows the town of Wilbraham in 1870—covering the town land from the Chicopee River on the north and the Scantic River on the south and to the Connecticut state line. It also shows some of the homes of the early residents and lists some of the businesses in the town. This is how the town looked geographically prior to its dividing into two towns—Wilbraham and Hampden—in 1878.

IMAGES
of America

WILBRAHAM

Coralie M. Gray

ARCADIA
PUBLISHING

Published by Arcadia Publishing
Charleston, South Carolina

Printed in the United States of America

Library of Congress Catalog Card Number: 2001093532

For all general information contact Arcadia Publishing at:
Telephone 843-853-2070
Fax 843-853-0044
E-mail sales@arcadiapublishing.com
For customer service and orders:
Toll-Free 1-888-313-2665

Visit us on the Internet at www.arcadiapublishing.com

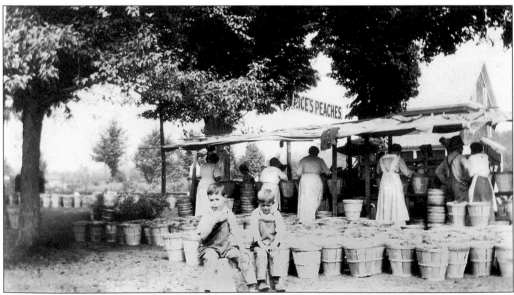

Women were hired to sort the peaches and apples. This view shows some at work in the sorting shed. Originally, sorting was done near the crop; however, by the 1940s, sorting and selling was conducted on Main Street. Its final location is in the barn where all manner of produce is sorted, stored, displayed, and sold. This proved best once oxygen storage became available to fruit growers. (Courtesy Jesse Rice.)

CONTENTS

ACKNOWLEDGMENTS

As a historiographer and archivist, I have enjoyed the three written histories of our town. To write a fourth history would be to regurgitate the past three and merely add some catch-up information. After reading the town library holdings of the Images of America series, I became interested in perhaps trying to do one for Wilbraham. Thanks to Joe Rodio, assistant director of the town library, I obtained the address needed and, with his encouragement, pursued the venture. When I received the materials, I thought, "What have I gotten myself into?" However, as various residents shared their pictures with me, the enthusiasm grew and I began to have fun. Newer residents deserve the chance to see their town "as it was," to learn about its history, and the older residents to remember.

I must thank my son Steve for putting up with the piles of materials stacked in the dining room, late dinners, and haphazard housekeeping. The Wilbraham Historical Commission materials were of invaluable help. To Paul Murray and his collection of postcards, Jesse Rice and his photographs, David Bourcier for searching through the fire department's archives, Mark Paradis and his police photographs, Denny Smith for his farm photographs, Dorothy Bednarz for her wonderful photographs about town, Peter Ablondi, MaryEllen MacLean, the Academy Archives, the Atheneum Society of Wilbraham, and the Wilbraham Town Archives. To all a profound thank-you. May all who read this book enjoy it—nonresidents and residents alike.

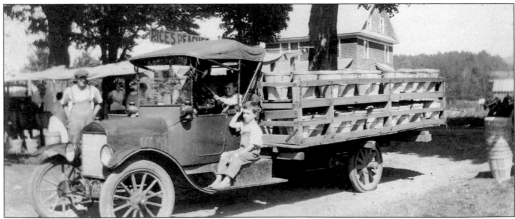

As the peaches were sorted, they were loaded on wagons or trucks for the trip down the mountain to the packing area for distribution. This was a slow trip, so as not to bruise the fruit. Children enjoyed riding the wagons or trucks, which gave them the feeling of helping and being part of the harvesting. (Courtesy Jesse Rice.)

INTRODUCTION

Wilbraham, Massachusetts, has a proud and interesting heritage. The Nipmuc Indians used the area as a three-season camping ground. They canoed up the Connecticut River to the Chicopee River and onto Twelve Mile Brook. They had camping grounds in various areas of the town, where they hunted, foraged, and picked berries. There was a long-lasting industry—quarrying in two soapstone outcroppings, where they fashioned many implements that enriched the lives of Native Americans in the greater Springfield area and beyond. They made bowls, pipes, scrapers, pestles, hand hammers, arrowheads, spear points, plow heads, hoes, and other utensils used in everyday life. This was one of only two such quarries in the Pioneer Valley—the other in Westfield is now gone. There is a Native American grouping on display in Springfield at the Quadrangle in the science museum. One of the large Wilbraham soapstone boulders is the centerpiece with a Native American brave working on making a bowl, a Native American woman at a campfire cooking, and another Native American brave bringing in food he has hunted. By the time Wilbraham was beginning to be settled, there were not many Native Americans left in the area.

The town was originally a part of Springfield, as it had been purchased from the Native Americans by William Pynchon in 1674. When the threat of its reverting to the Royal Crown arose, the land was divided between 125 Springfield residents into what became known as "the Outward Commons." In 1728, a Springfield resident purchased land in the area and settled in 1731 along what is now Main Street. More followed and the area soon grew with farms, homes, and businesses. The settlers had to travel into Springfield on the Sabbath and spend the entire day there. This was a hardship and, in 1740, they petitioned Springfield to let them become a separate precinct, thus allowing them to call their own minister and establish their own church and governing body. In 1763, the town was incorporated and Wilbraham was born.

The town ran from the Connecticut line to the Chicopee River. With such a distance between the North Parish and the South Parish, once again the hardship of travel to attend church and town meetings arose. Town meetings alternated between the two parishes, yet church remained the same. As early as 1772, the South Parish asked to be set off as a town, but it was not until 1878 that the parishes divided; the South Parish became the present town of Hampden, and Wilbraham assumed its present boundaries. The Old Bay Path ran through the town into Springfield, and thus a turnpike from Warren to Wilbraham was in operation for a time. General Washington, Colonel Knox, and Burgoyne traveled over the Bay Path through the town during the Revolution. In 1823, Wesleyan Academy moved from New Hampshire to the center of town, and this shifted the population and its center from the north end of town to what is still the geographical center. With the influx of students from all sections of the United States, as well as international students, the population of the town increased dramatically. The youths of the town were educated for their high school years at Wesleyan. Townspeople attended concerts, debates, theater, and sports on the academy grounds and generally used it

as their cultural center—town meetings were held in the academy buildings, and the school provided Methodist ministers to three of the town churches. There were the usual taverns, stores, blacksmith shops, farms, inns, stagecoach livery stables, churches, and small businesses. The mills along the rivers bordering the town—Chicopee in the north and Scantic in the south—used waterpower to run the mills. When the Quabbin Reservoir was constructed in the 1930s, the level of the water in the rivers was affected and effectively brought about the demise of these particular businesses. When in its prime, the Collins Paper Mill produced fine-quality paper, some of which was used for currency by the United States. The mill provided quite a bit to the life of the town. Millworkers' housing was along Cottage Street, and the houses along Maple Street were the places where managers and officials lived. Grassy Hollow was a park built for use by all for picnics and had several playing fields. Sadly, this was destroyed when the park was taken over for the current landfill. There were large farms—some of which are still in operation. When a town resident decided to grow peaches and set out orchards on the side of the mountain and the crop was successful, others planted trees, and soon there were many peaches in the town. Two of these peach orchards—Rices and Green Acres—are still in operation with their orchards on the mountain. There are other farms still in operation—Bennett Turkey Farm and Merricks Farm, on Main Street, and the Oaks Farm, on Stony Hill Road. Once the season for peaches arrives, the town bustles with heavy traffic of those who want to can the fruit, as well as eat it out of hand. Peaches have become what Wilbraham is most noted for, with a three-day Peach Festival held every year. There is a parade; a pancake breakfast; concerts; an antique car rally; booths of crafts, artwork, and food; fireworks; and a road race. In 1998, the Peach Festival was designated a Local Legacies Project by the joint effort of Congress and the Library of Congress to be housed in the Archives of American Folk Culture, Washington, D.C. This celebrates the grass-roots activities of America. With the purchase of the state-owned Pheasant Farm on Tinkham Road, the festival has a permanent home in what is now called Fountain Park after the man who donated the land to the town.

One

EARLY WILBRAHAM

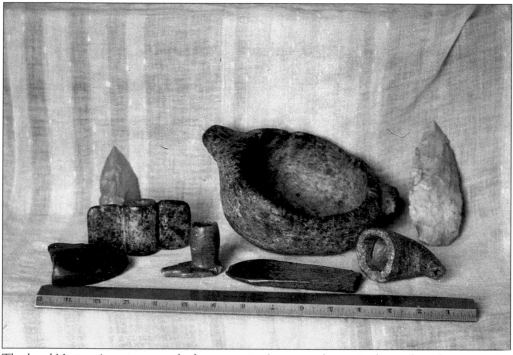

The local Native Americans worked two steatite (soapstone) quarries located on the mountain. They produced implements that helped many Native Americans to a better life, not only in the local area but far afield as well. The soapstone implements lasted longer than pottery ones and provided a good trade item. These in the picture are on exhibit in the Natural Science Museum at the Quadrangle in Springfield. Wilbraham also has a collection of soapstone artifacts as well—scrapers, bowls, a pipe in process, arrowheads, spear points, hand hammers, plow heads, digging tools, pestles, and cutting tools to name a few. There were only two steatite quarries in the general area—one in Westfield and the other in Wilbraham. The one in Westfield is gone, leaving only the Wilbraham locations. The items are put on display or displayed along with a talk at various times, thus giving inhabitants of the town an indication of its earliest history. (Courtesy L. Merrick.)

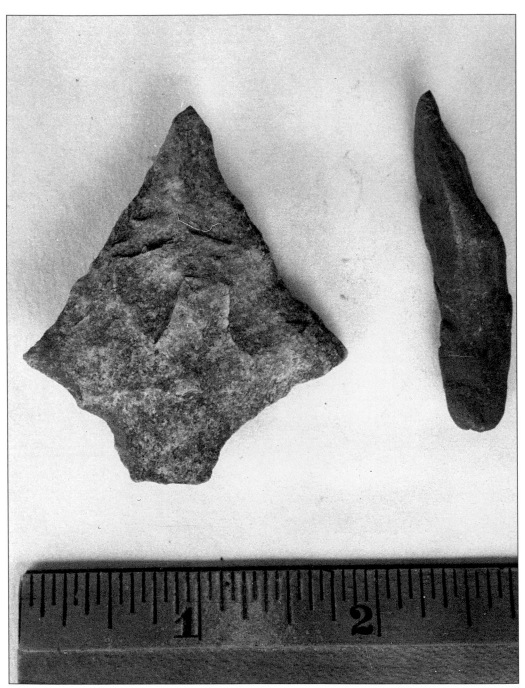

This is a picture of an arrowhead and small awl—giving an indication of their size. People still find articles when gardening or during construction. When historical artifacts are uncovered during construction or developments, the builder is required to stop and have an archaeologist check out the area. This is to determine the historical importance as indicated through the find and sometimes requires that changes be made to the original development or construction plans. Several developers have deeded land to the town, thus preserving history and showing good faith. (Courtesy L. Merrick.)

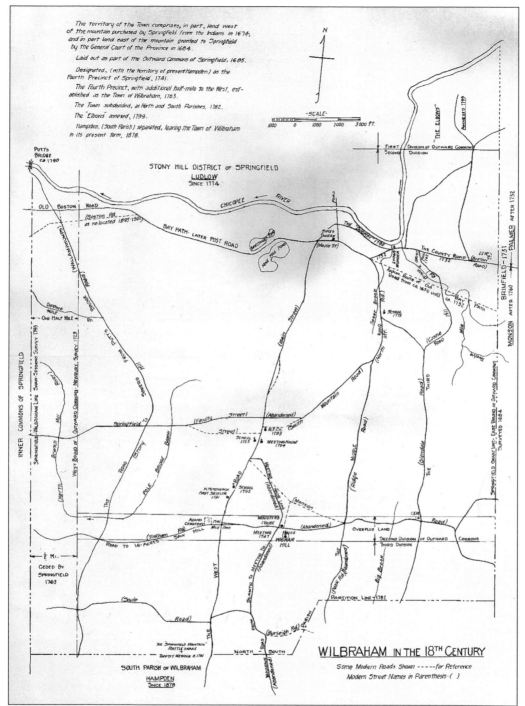

This map shows the Outward Commons divisions, old roads, rivers, some businesses, how some of the roads were changed in later years, street names originally used, and the Old Bay Path in conjecture, there being no available documentation other than written description. The map also shows the change to the Old Bay Path with the construction of the County Road in 1732 and adjacent towns with their eventual name changes. (Courtesy L. Merrick.)

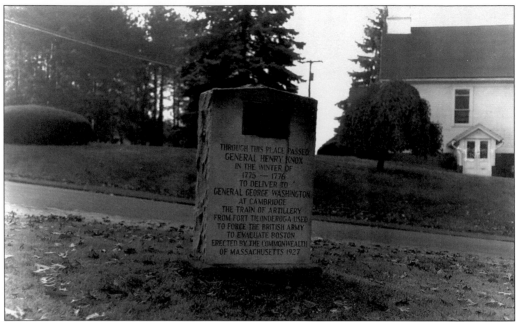

In the winter of 1775–1776, General Knox did the impossible—using an oxen train, he and his men transported a line of artillery, which included heavy cannons, from Fort Ticondaroga to Gen. George Washington in Cambridge. This trek was conducted over hazardous roads and territory and through Wilbraham along the Old Boston Road, continuing up what is now called Maple Street to the Old County Road, down to the Boston Road known as Route 20, and on in to Cambridge. The British evacuated Boston because of the appearance of the armament.

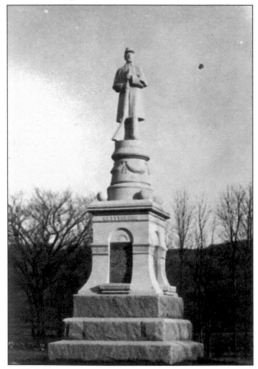

This monument is typical of all small towns in America. It stands on the village green, known as Crane Park. Originally, the Wilbraham Town Hall was to be built here, but, due to a difference of opinion among townspeople, the town hall was never built. Lucia Foskit of town gave the monument to the town, as well as the Grange Hall, in memory of her husband, Dr. Stebbins Foskit, a prominent physician.

Two

STREET VIEWS, CHURCHES, AND HOUSES

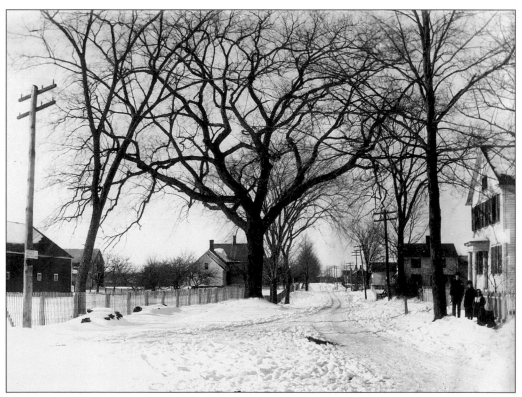

Springfield Street is one of the main roads leading into town. Usually the streets were named for the area to which the road led. Hence, Springfield Street leads to Springfield and, at the Springfield line, the name changes to Wilbraham Road, as it leads from Springfield into Wilbraham. Another road with the name of Wilbraham Road is at the southern end of Main Street, which leads from Hampden to Wilbraham. Springfield Street originally continued along what is now Faculty Street until the Springfield Street section from Faculty Street to Main Street was laid out. (Courtesy L. Merrick.)

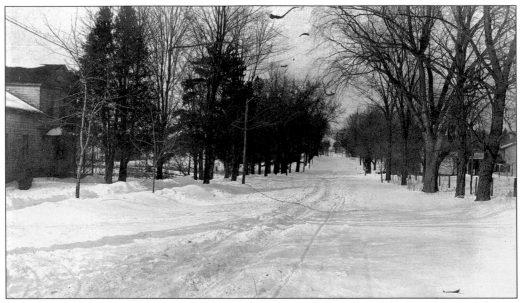

These views looking north and south from the center show some of the businesses no longer in town, as well as some of the houses still standing. The center built up after the arrival of Wesleyan Academy in the area. Originally, Maple Street and Boston Road were considered the center of the town—and businesses. The geographic center is the present center of the town at Crane Park.

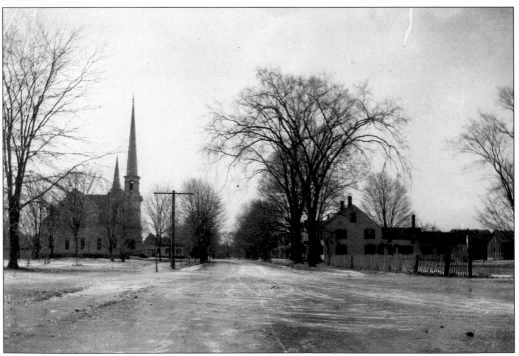

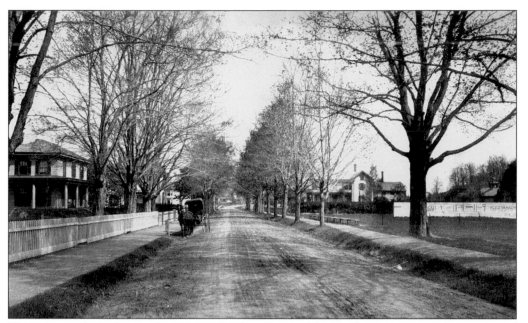

These views show the academy grounds, churches, and houses leading toward the north end of town. With a few exceptions, not too much has changed in this view today. Several of the houses beyond Rich Hall now belong to the school and are used for faculty housing. Many of the houses were built by men teaching at Wesleyan.

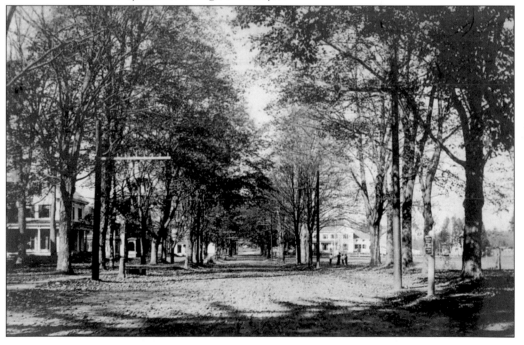

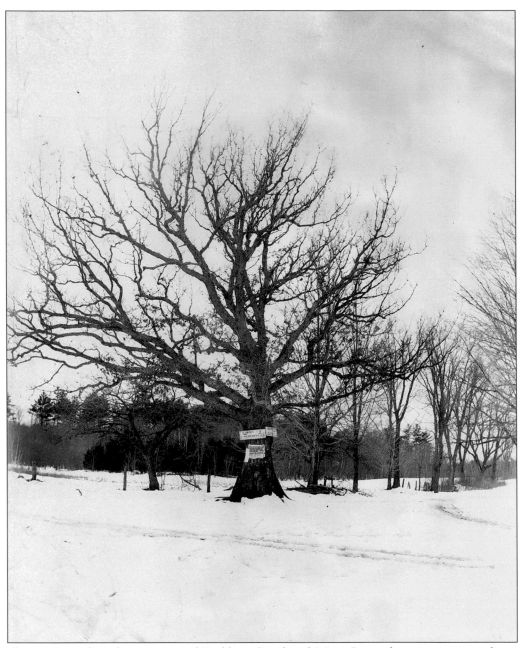

This tree stood at the junction of Tinkham Road and Main Street for many years and was known as the Mile Tree. This was because it was used as a marker for one mile from the junction of Springfield and Main Streets. There is an area called "four-mile square," which indicates Springfield Street west to Stony Hill Road, south on Stony Hill to Tinkham Road, east on Tinkham Road to Main Street, and north on Main Street to the center and Springfield Street. Several track teams train using the "square." The tree was a black oak and stood in the center of a V at the junction of the two streets. All residents of town were upset when the tree was taken down in 1958. It was over 200 years old! (Courtesy L. Merrick.)

This photograph of the old Mile Tree in later years shows how large and beautiful it was. The view is looking west from Main Street. The house beyond the tree was the home of Deacon Adams, whose land ran adjacent to the cemetery on Tinkham Road. It has since come to be called Adams after him. (Courtesy L. Merrick.)

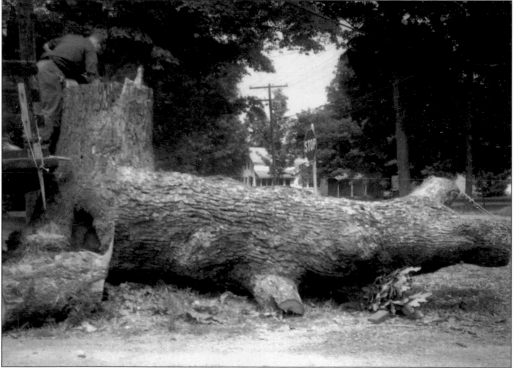

This snapshot was taken on the sad day the Mile Tree was cut down. Note the wide girth!

Federal Lane originally led from Main Street easterly to about where Old Meetinghouse Lane is located. This evidently was a lane used by parishioners going to and from the meetinghouse, then located on upper Tinkham. The lane was discontinued in 1899. As this picture shows, you can still see where the lane was.

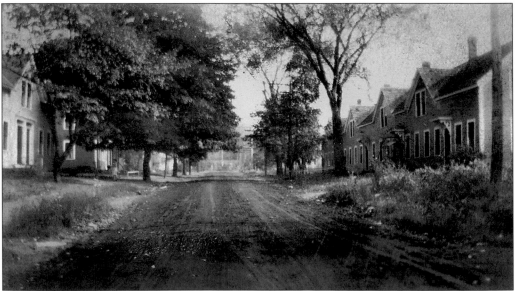

This view of Cottage Street is looking south toward the underpass in North Wilbraham from the Singing Bridge across the Chicopee River. It still has the housing provided by the Collins Manufacturing Company for its workers. The large house was known as the "Beehive," as it housed eight families. There are some single-family houses still there on the other side of the street.

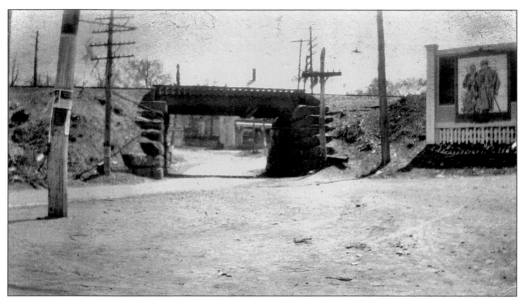

The North Wilbraham underpass was the scene of many accidents due to poor vision for the drivers. Just looking at this picture shows why. It was boarded up and the present one built in a new location on Boston Road with the train tracks above.

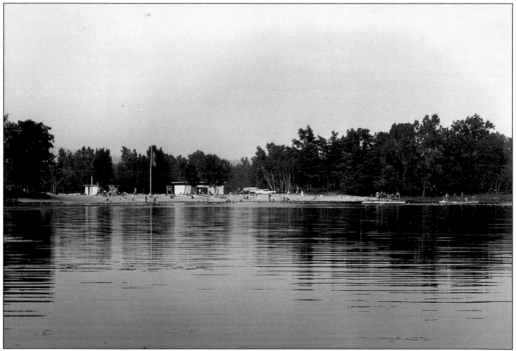

This is a picture of the town recreational and swimming area, located on the north side of Boston Road. It is called Spec Pond because the pond is in the shape of a pair of spectacles. The Lions Club started the area, and then the town recreation department took it over. There is a summer camp, an area for townspeople to sun and swim, picnic areas, fishing areas, and a pavilion for group use. It is a much safer spot than the original town beach on Nine Mile Pond. (Courtesy L. Merrick.)

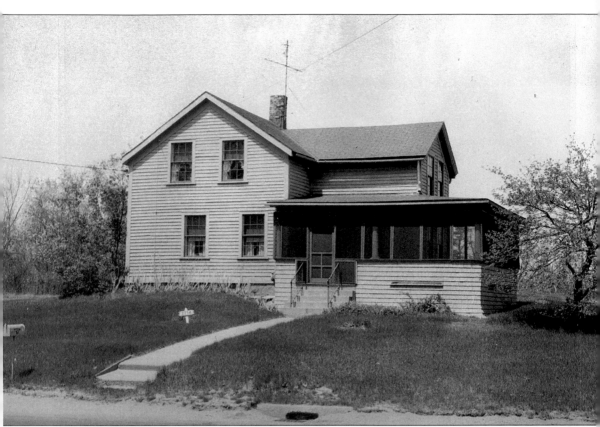

Catholic masses were celebrated in this home once a month since 1870, although masses had been said since 1831 at various missions. The priests would go to the home and conduct a mass, often in a kitchen, kneeling at the kitchen table used for an altar. Today, newest St. Cecilia Church is a far cry from the one started in the kitchen of Bernard Lynch on Boston Road. (Courtesy L. Merrick.)

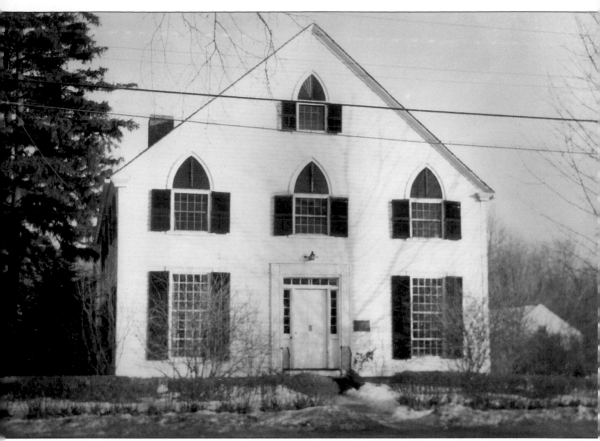

The Old Meetinghouse, located on the corner of Mountain Road and Main Street, was built in 1793 for use by the Methodists of the town. The land had been donated to the Congregationalists for the construction of a new meetinghouse. They originally accepted but later refused, causing the angry owner to offer the land for use by the Methodists. The Methodists happily accepted and erected their meetinghouse, paying one peppercorn a year for rental of the land. The Methodists worshiped here until 1835, when the building became too small. It was sold for use as a private home. The new owner inserted a second floor, put in partitioning walls, separated the front windows (making upper and lowers instead of a single), and added a porch in the rear. The ridge pole of the building is one continuous tree trunk 45 feet long, and some of the support beams under the first floor still have bark on them. The building is now owned by the town and leased to the Atheneum Society, which maintains it as a museum for the people of Wilbraham. The rent once again is one peppercorn a year.

The Methodists built a second meetinghouse across the corner of Mountain Road. It was also a clapboard building and used from 1835 to 1856, when once again more space was needed. The second meetinghouse was moved east of its original site, where it was used as a music and art building by Wesleyan Academy until 1921 and then torn down. In 1867, the third meetinghouse was built where it stands today. This meetinghouse was constructed of yellow sandstone quarried locally from the Merrick quarry on Main Street and the Hitchcock quarry on Stony Hill Road. Over a period of time, the Methodists gave the Congregational church the use of their church during a few times of need and, eventually, the two joined, forming the United Church of Christ, which is now the United Church farther south on Main Street. The Stone Church was deeded to Wesleyan and is still in use for many purposes. It is now called the Alumni Memorial Chapel.

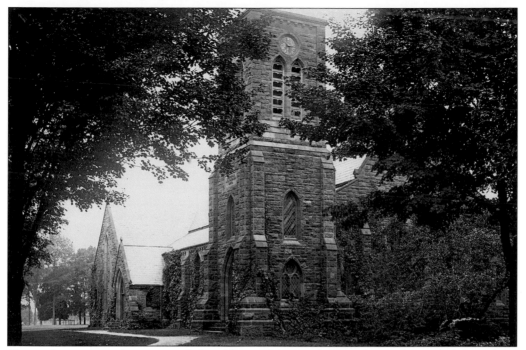

Shown here is another view of the Alumni Memorial Chapel, which is used for school meetings, weddings, concerts, lectures, presentations, memorial services, and a myriad of other uses. It has recently been refurbished, at which time the tall stained-glass windows above the altar area were found to still have red stained glass in them. They need to be repaired, which will be done at a later date.

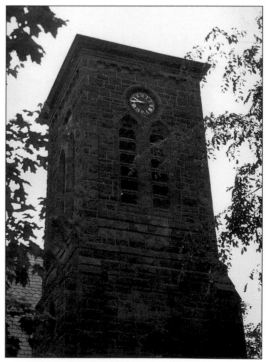

The town clock is on the chapel tower. There are three faces allowing viewing from the north, south, and west. It was donated by Col. Benjamin Butler and has allowed town residents to set their house clocks from this one for many years. A local story related over the years is that a resident who lived south of the church at a distance would blow a horn at nine each evening, allowing those farther away to set their clocks to that hour. The clock is still in operation today. (Courtesy L. Merrick.)

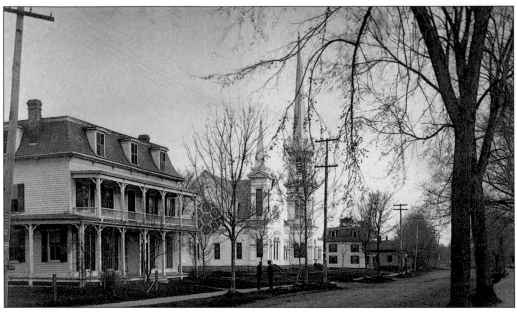

This view to the south of the center shows the Allis hotel and the Congregational church. The hotel was a favorite of people from Springfield for summer vacations in the cooler weather of the town and for traveling men, salesmen. There was a large ballroom on the second floor, where biweekly dances were held. (Courtesy L. Merrick.)

WESTERN RAIL ROAD.

CAMP MEETING

AT

WILBRAHAM!

Sunday, Aug. 25, 1867.

A Passenger Train will Leave SPRINGFIELD for Wilbraham, on Sunday, Aug. 25, at 9.00 A.M.

RETURNING, will leave Wilbraham for Springfield at 5.30 P. M.

Persons not purchasing tickets at the ticket office will be charged full fare.

Fare to Wilbraham & Return 50 cts.

C. O. RUSSELL, Sup't.

Office Western Railroad Co.,
Springfield, Aug. 23, 1867.

This broadside gives information of the train schedule, so people in surrounding towns would be able to attend a planned camp meeting in 1867. Camp meetings were a common occurrence of the time, and a large number of people would attend these religious gatherings. (Courtesy L. Merrick.)

Shown to the right is one of the several Congregational churches to be built on this site. It is the second Congregational church, which served until 1911, when it was struck by lightning and burned. Another was built on this site and used until 1958, when the people moved into their new church, now enlarged into the one that stands today on the corner of Woodland Dell Road and Main Street. The second picture shows the 1911 church, which stood where Gazebo Park is now.

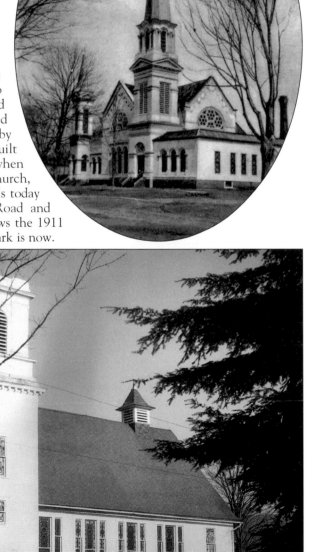

This is another view of the Old Meetinghouse and the Stone Chapel. It shows the second meetinghouse then in use for an art and music building by the school.

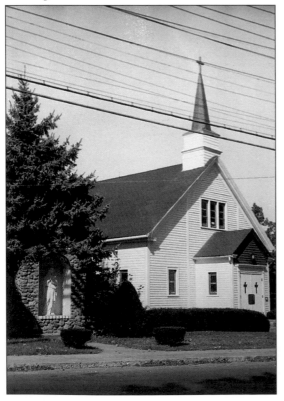

Here is a view of the original St. Cecilia building on the corner of Main and Maple Streets. It was a mission served by priests from Palmer until it became a parish with its own priest in 1951. The current, larger St. Cecilia Church farther southeast on Main Street is attended by more than 6,000 parishioners. (Courtesy L. Merrick.)

The people in the north end of town used to attend the Congregational church in the center of town, but when the paper mill was started, more people moved into town. It was a hardship for them to get to the center. Thus, it was decided to build a church in their area, where all could attend. In 1886, Grace Union Church was established. (Courtesy L. Merrick.)

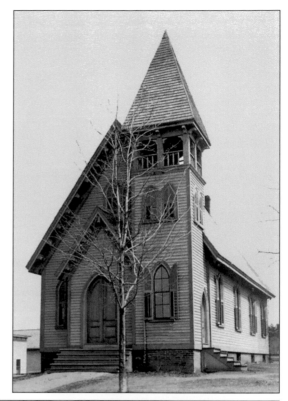

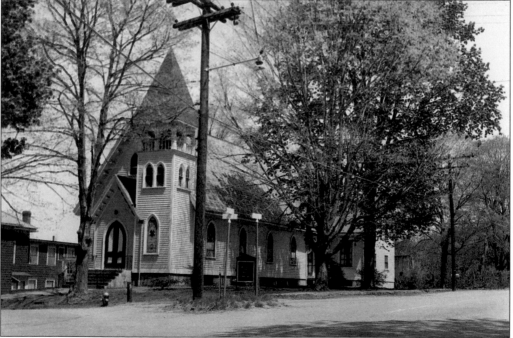

This view of Grace Union Church shows how it appears today. It has been expanded with the building of church schoolrooms, a dining hall, and a parish hall with more improvements planned. (Courtesy L. Merrick.)

Glendale Methodist Church is located at the junction of Monson and Glendale Roads. For many years, its preachers were supplied by Wesleyan Academy each Sunday when Rev. Edward Cook, principal of Wesleyan, was unable to attend. Glendale shared pastors with the church in Hampden for many years until the Hampden churches federated. The church has had its share of ups and downs over the years, yet it is still in operation. This view shows the original church and its location across the road from the the Glendale Cemetery. (Courtesy Denny Smith.)

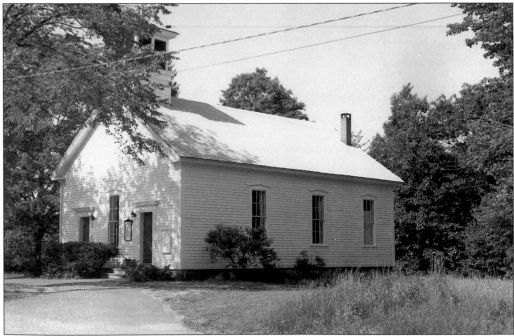

Here is the church as it appears today. The parishioners are busy with their missionary and educational projects. The Glendale School was bought by the church and named the Glendale Methodist Community House, where the church's famous chicken pot pie and strawberry suppers are held each year. The suppers are usually sold-out each sitting. (Courtesy L. Merrick.)

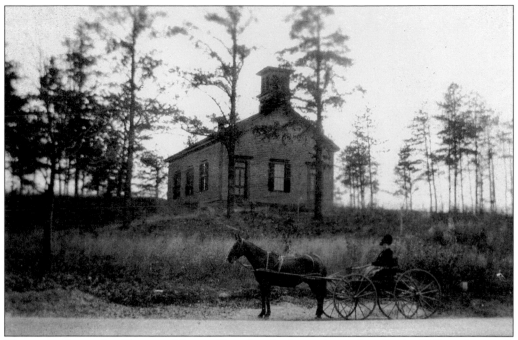

This view shows the Christian Union Church, which was located on Butler Hill in the north end of town on Boston Road near the Monson line. Built in 1868, it was open to all Christian denominations believing in the scriptures. It held its last meeting in 1923. The building was used for American Legion meetings, Ladies Auxiliary meetings, and by the Boy Scouts until the 1940s. (Courtesy L. Merrick.)

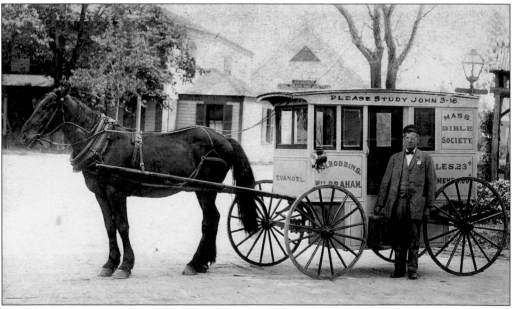

Religion has all sorts of ways to be expounded and taught. Fred Robbins was an evangelist who lived in the first house on Springfield Street past the barbershop. For many years, he traveled spreading the word for the Massachusetts Bible Society. At first, he traveled by bicycle and then became the proud owner of this ex-mail cart and horse. (Courtesy L. Merrick.)

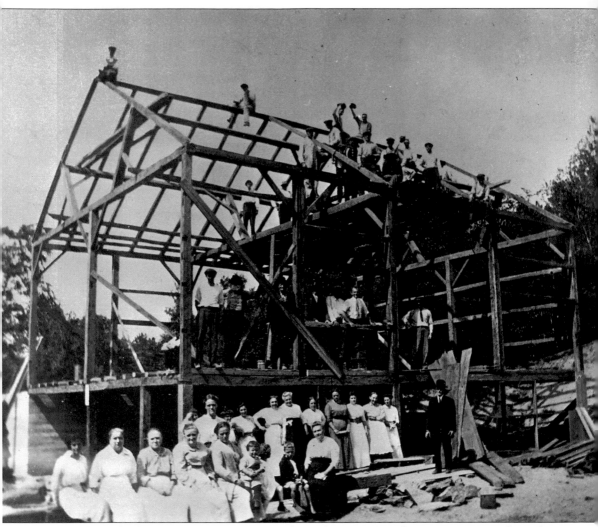

People made their own entertainment in the early years. One favorite way was either a house warming or a barn raising. Here you see the men up in the rafters and among the timbers while the women have gathered to set out the food for all. The raising took most of the day, and the women timed it so all was ready when the framing was completed. There would be feasting, dancing, and music. The children would run around and play games. It was a good way to put some enjoyment into what could be a difficult and hardworking life. The many hands of neighbors helped each other, as they relied on one another and were always ready to help when needed.

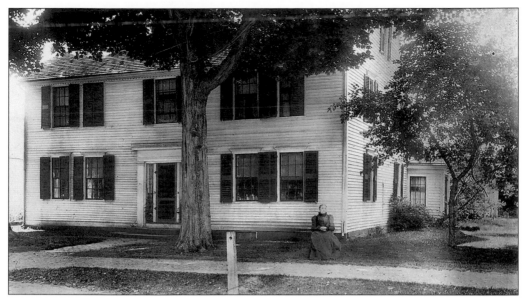

Many residents conducted their businesses within their homes or at the homesite. Isaac Brewer maintained an inn at his house south of the center gas station. This was an early tavern where town meetings were held and where the stage stopped. The committee to build the first meetinghouse up on Wigwam Hill met here in its planning stages. Worship was held here until the meetinghouse was ready for use. Brewer's son Charles was instrumental in bringing Methodism to the town. (Courtesy Paul Murray.)

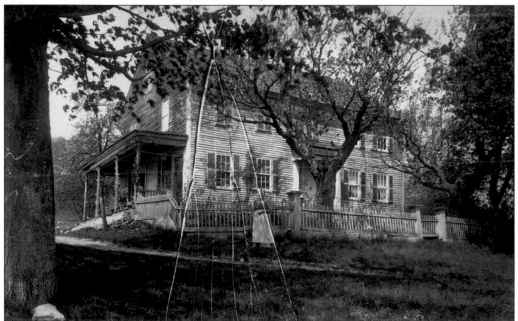

This is the Rindge House at 471 Glendale Road. It is known also as the Century Homestead, as the same family lived in the house for more than 100 years. Many homes in the town were passed down through the generations or rooms were added on as children married. In farming, the children were needed to help with the work, and being separate yet part of the home was a good solution. (Courtesy L. Merrick.)

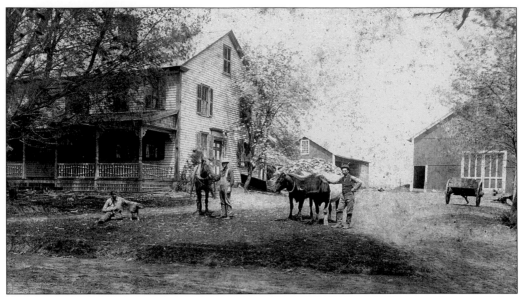

The Denny Smith residence on Monson Road has had a long and illustrious history. It has been in the Smith family for some years and is one of the few farms in the town that has kept its original form, as there have been few alterations other than the addition of a porch. At one time, the home was owned by Evanore Beebe, who had an extensive collection of antiques and china. Because of the many large maple trees, she called the home Maplehurst. (Courtesy Denny Smith.)

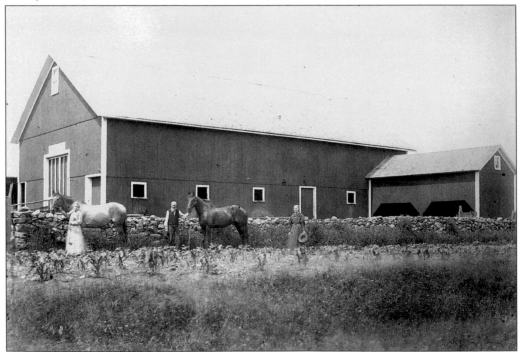

This is another view of the Smith farm, showing the family's large barn and horses. People were very proud of their livestock and had their pictures taken with them quite often. (Courtesy Denny Smith.)

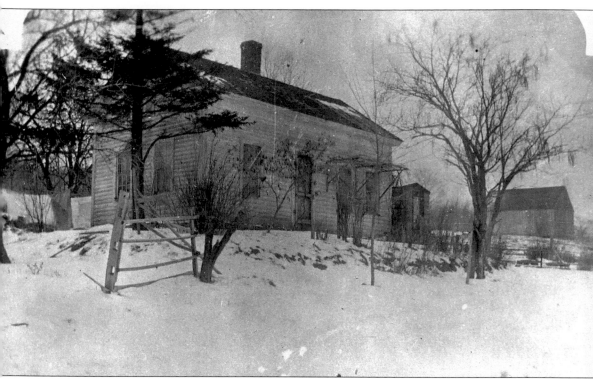

Wilbraham believed in freedom from slavery, and its people were active participants in the Underground Railroad. Slaves were brought into holding areas and then escorted up the mountain to the Glendale area, where they were fed and protected until the next portion of their trip to Canada. A house next to the village store had a secret cellar that few members of the family were aware of. Only when the house was torn down was the cellar found. It is also reported that there was a tunnel connecting the cellar of the Old Meetinghouse to the cellar of the Stone Church across the corner. The building of the church was delayed due to the Civil War, and the cellar had been capped. Recently, a lady from Canada came to town and told how her great-great-grandfather had gone through Wilbraham with the Underground Railroad and had been part of the tunnel operation. It is good to know that he made it to Canada and to have that story verified. This house, Calkins, in the Glendale area was an active part of the Underground Railroad network.

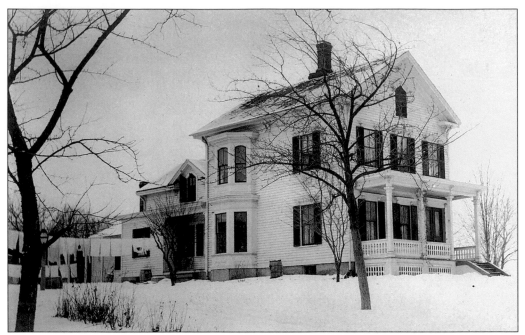

These are some examples of houses in the town. Many of them are still in use today and have been restored or renovated. The houses along Maple Street, in the northern part of the town, are a collection of styles of the early history of the town. The other house is located on Boston Road. One was built in 1894 and the other in 1879.

This is a prime example of a Victorian house, as well as an example of clothing worn at the time. Note the use of different colors on the house, shrubbery with gate, and chairs on the porch so people could talk with passersby. The tree in front of the house has reached large proportion now with an impressive girth. Most of the houses built on Faculty Street were just that—homes of Wesleyan faculty.

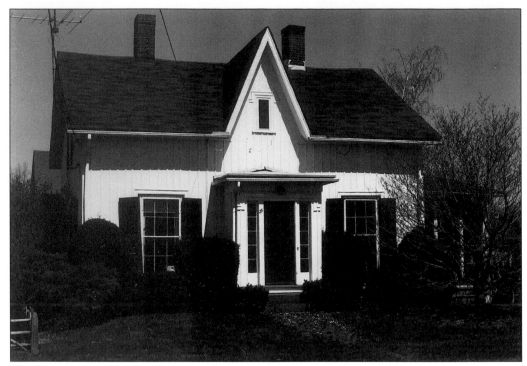

The houses along Faculty Street are listed on the National Register. The diversity in style of the houses is interesting. This is a Carpenter Gothic that you do not see too often in this area. Note the vertical siding.

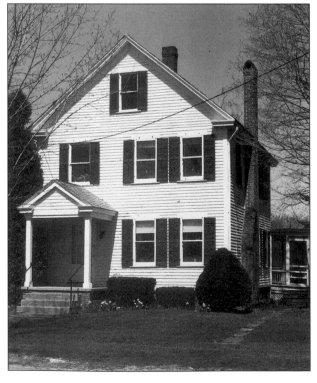

This is an example of a Greek Revival house that is quite common in New England.

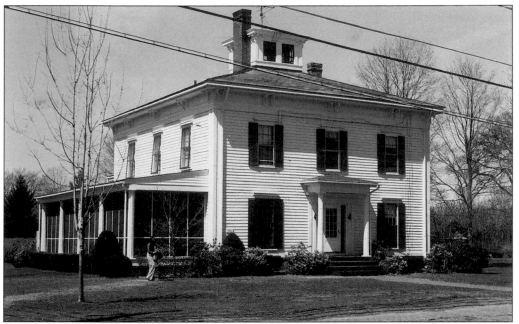

Here is the second headmaster house, built in 1855 to replace the original headmaster house. The original house was moved west onto Faculty Street and used as a dormitory, faculty housing, and, later, an infirmary. The second house is larger and more in keeping with what the trustees felt the headmaster should have for a home.

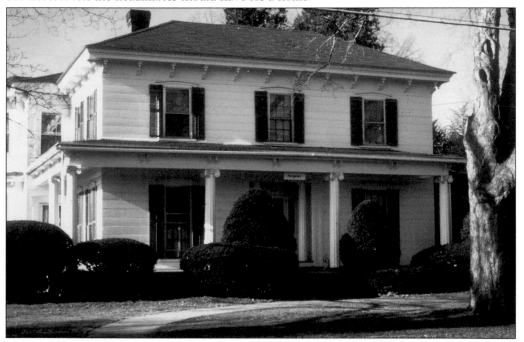

This is Hodgkins House and part of faculty housing. It was owned for 20 years by Benjamin Gill, after whom the academy library is named. Louise Manning Hodgkins, a writer and lecturer, was the last owner and deeded the house to the school. It was used as a middle school dormitory and is now faculty housing.

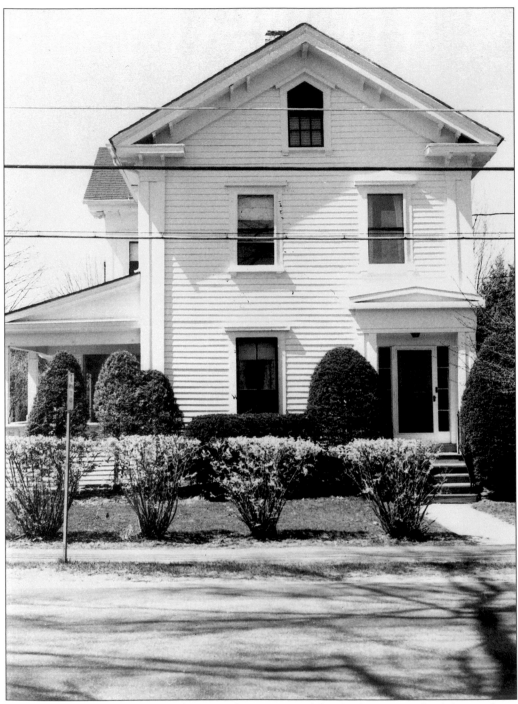

The Chapin House has been a home, a dormitory, and faculty housing. All of the academy houses along Main Street are a part of the historic district and are on the National Register.

This view of Main Street, taken from across the street on the baseball field, looks south toward the center. It shows another part of the historic district.

Here is a view of Main Street looking north, taken from the lawn of the Old Meetinghouse. It shows the house that is now the Main Street Cat Clinic, the Green-Bartlett House, and Rich Hall. These are the southernmost parts of the Academy Historic District. There is a study taking place with thought of including this current national district in a proposed overlaid local historic district.

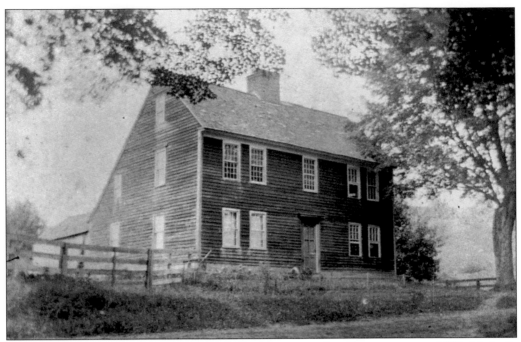

This is the house of Lt. Timothy Merrick, a young man planning to marry in 1761. He built the house and was haying when he was bitten by a rattlesnake and died. This incident became famous through folk songs sung at the time and continuing today. Many famous singers have recorded this song and sung about it in concert. The house passed to the Bliss family, who added a porch and lived in it for a number of years. (Courtesy L. Merrick.)

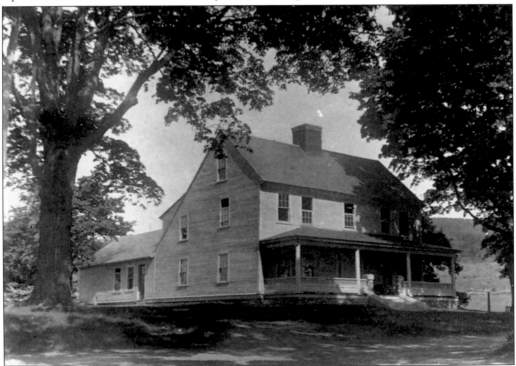

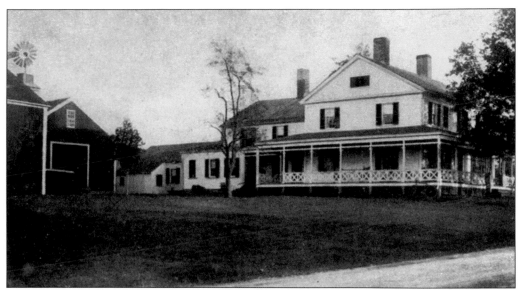

This is a historic part of the town—the Bliss-MacLean House on Main Street (called by many the Llama Farm). It was the home of the Bliss-Gillett family and is part of one of the original lots that comprised the Outward Commons. The land goes from Main Street up the mountain. (Courtesy L. Merrick.)

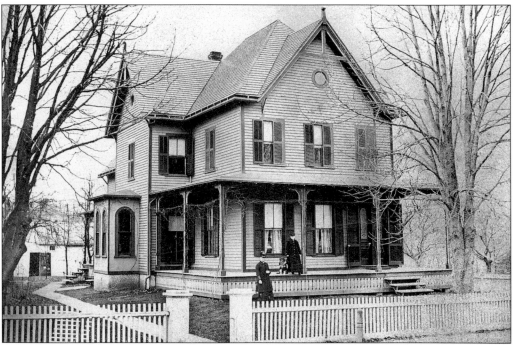

This is the Bolles house, located on the mountain where Upper Tinkham Road and Bolles Road connect. This house is next to the place where the first minister's house stood and adjacent to the first meetinghouse site. Originally, the road continued eastward up the mountain to Ridge Road, where it met with Meetinghouse Lane; however, that section was discontinued in the late 1850s–early 1860s. The road leading in to the Bolles farm from Monson Road became the connection with Tinkham Road.

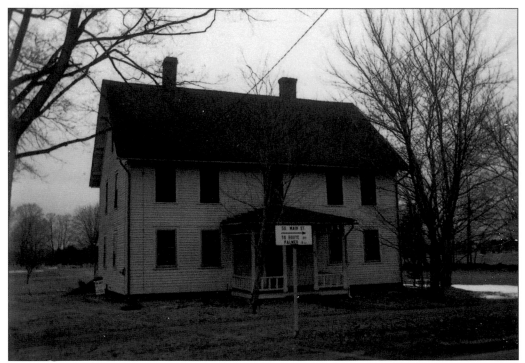

This is a view of the Deacon Adams House at the corner of Tinkham Road and Main Street. His land ran to the cemetery on Tinkham Road, and that is why the cemetery is named after him. (Courtesy Peter Ablondi.)

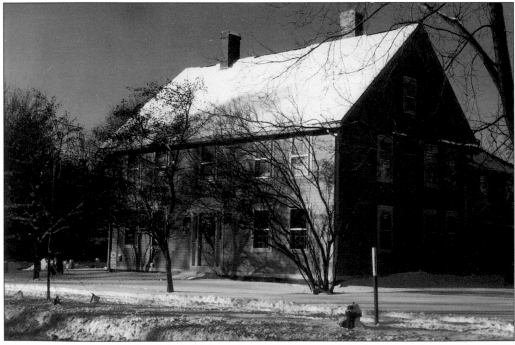

The second view shows the Adams House after it was restored. The house was built in the 1700s and situated next to the Mile Tree. (Courtesy Peter Ablondi.)

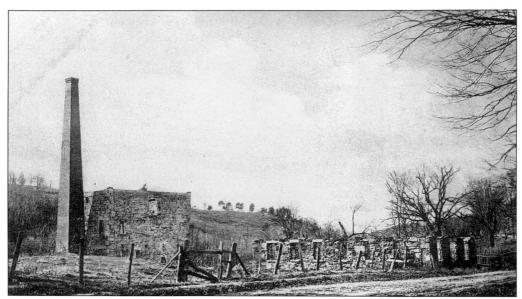

These are some views of the town of Hampden, which was originally the south parish of the town of Wilbraham until it became a separate town in 1878. The remains of the mill are along the Scantic River, which was used for hydroelectric power. The Allen House was used as an inn and a stage stop. This was an important part of Wilbraham with its many mills and businesses along the river.

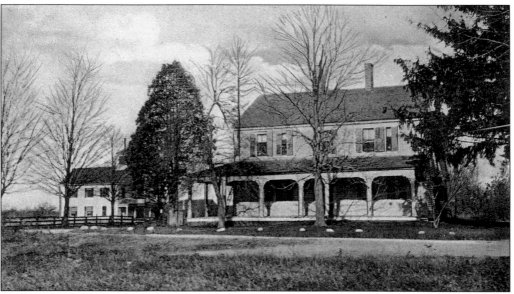

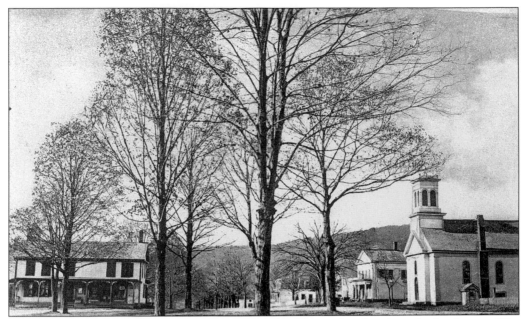

The view of the center of Hampden shows the Allen House, the church, and other homes. The ravine is of local interest. Hampden has many picturesque homes and areas, which reflect the life in the town while still the south parish of Wilbraham.

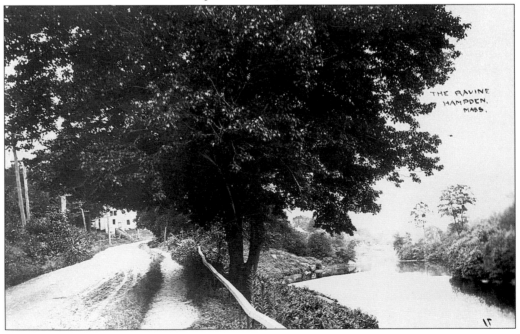

Three

HURRICANES
AND FLOODS

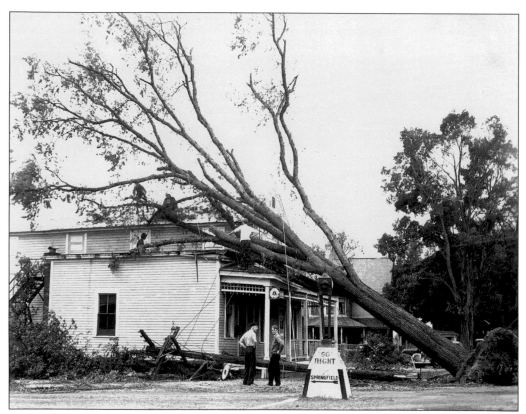

In 1938, the hurricane came roaring through the town and uprooted hundreds of trees. This photograph shows a tree on top of the Old Corner Store. Note the traffic island at the end of Springfield Street with a blinker on top. It was usually so quiet in the town by 8 p.m. that you could hear the blinker go on and off. (Courtesy L. Merrick.)

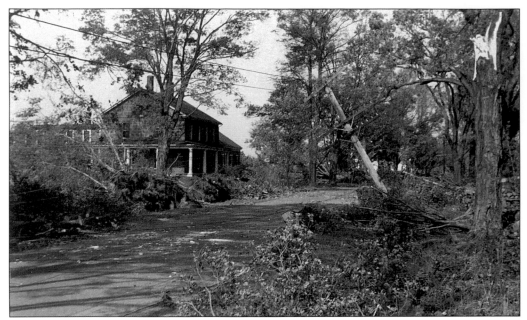

Here, the brick Merrick house on South Main Street has been covered and surrounded with uprooted trees. Wires are down, and the road has just been cleared for traffic. This scene was duplicated all along Main Street. It was practically treeless along Main Street after the hurricane.

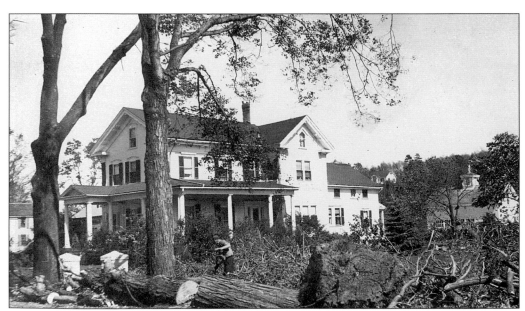

This is the Brooks house (now Pacosa) adjacent to the road up to the science building. The storm really took a toll of the trees around the house and in the road. Now there is an iron fence around the property. With the sustained winds, much damage was done.

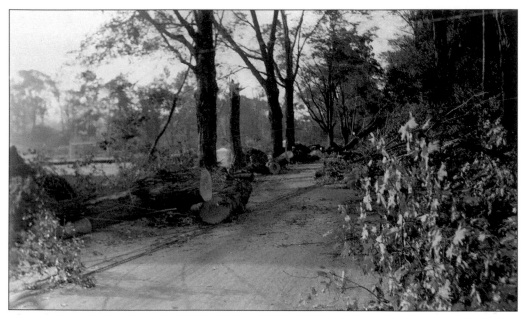

This photograph shows the north end of town along Boston Road and the dugway by the Chicopee River. Wires and telephone poles were down, and the road was blocked as the clean-up took place after the storm.

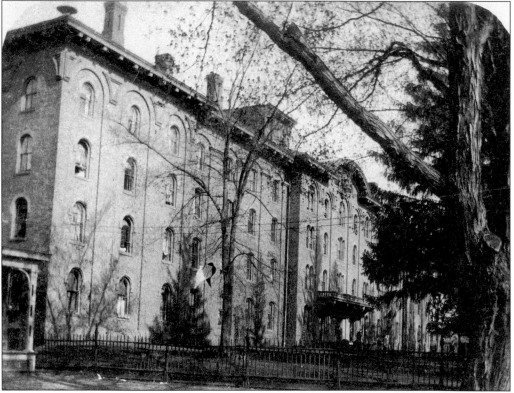

This picture of Main Street in the center and in front of Rich Hall shows the size and growth of trees that the hurricane demolished. The trees were stripped, and most had to be removed.

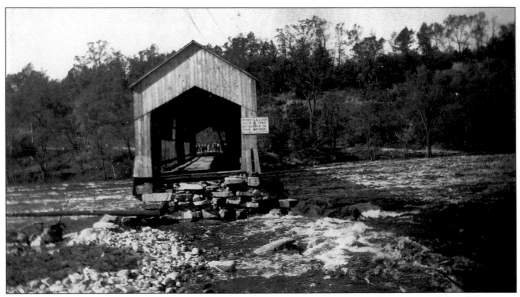

These are views of the covered bridge at the foot of Cottage Street that crossed the Chicopee River. Its foundation is about gone—amazing that it held up as well as it did. The bridge was taken down and replaced with the one now called the Singing Bridge. (Courtesy L. Merrick.)

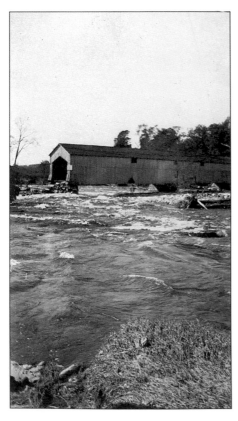

This is another shot of the covered bridge showing how it is barely being supported. (Courtesy L. Merrick.)

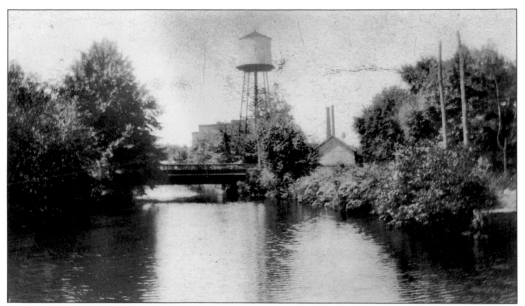

Collins Mill used hydroelectric power to work its machines. It had a canal from the river that directed the water through the turbines. The picture above shows the canal leading to the water tower before the Hurricane of 1938 and flood. When the Quabbin Reservoir was constructed, the level of water and volume in the river was lowered considerably and affected the mills' power source. The picture below shows the dam at the foot of Cottage Street washed out during the 1955 flood.

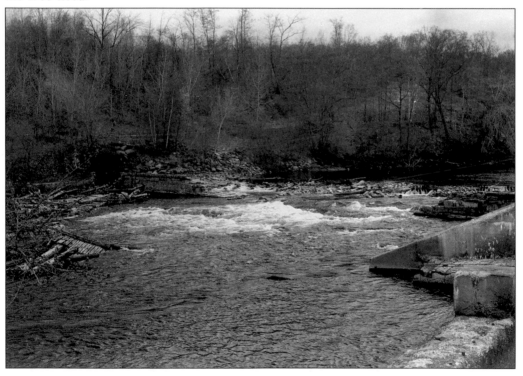

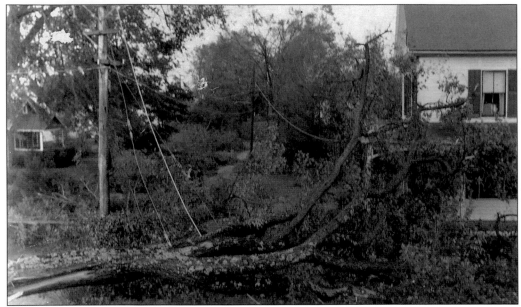

Here is a good example of the devastation created by the Hurricane of 1938. Trees were uprooted, many of them falling on houses. Wires, tangled in trees, were on the ground. Shown below is a house on Main Street in the center of town.

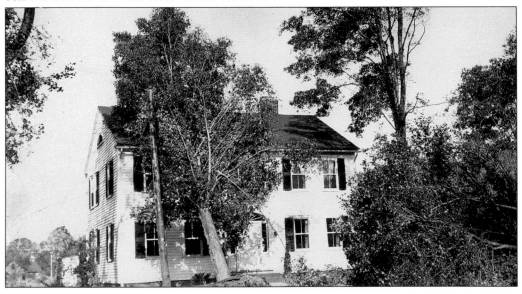

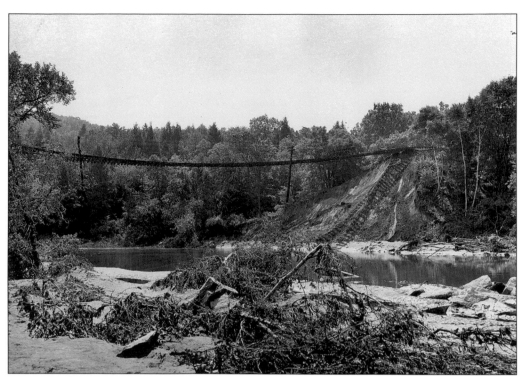

Twelve Mile Brook and the Boston & Albany Railroad tracks were hit hard with the 1955 flood. In this view, the telephone wires and poles are hanging, as are the tracks. Note the debris washed up on the shore. The insignificant brook became a raging torrent and left 250 feet of track suspended 60 feet above the brook. (Courtesy L. Merrick.)

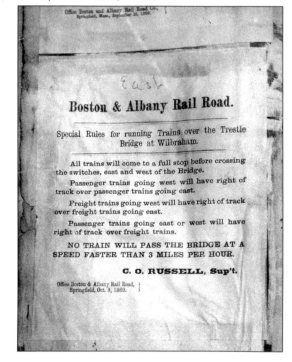

These are the rules set out for trains planning to cross the Twelve Mile Brook train bridge in 1869 after there had been a washout. The location was one that seems to have had many problems with washouts, even though is was originally a small brook. (Courtesy L. Merrick.)

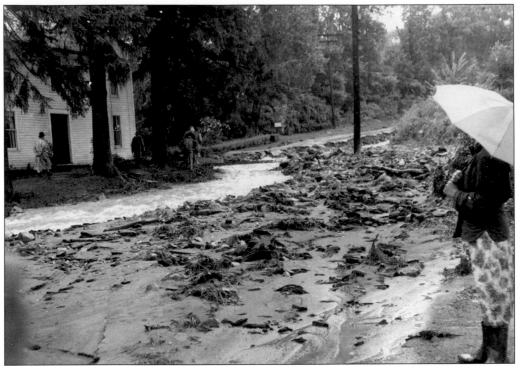

This view shows the destruction in high places. The road coming down the mountain in front of the Kittridge house and the Danforth house on Mountain Road was damaged by Spear Brook, which dug a 10-foot swath down the side of the road, flowed over to the barn, and caused the barn to collapse into a 15-foot hole it dug. Note all the debris. It took 6,000 cubic yards of fill to restore the grades on the Kittredge property. (Courtesy L. Merrick.)

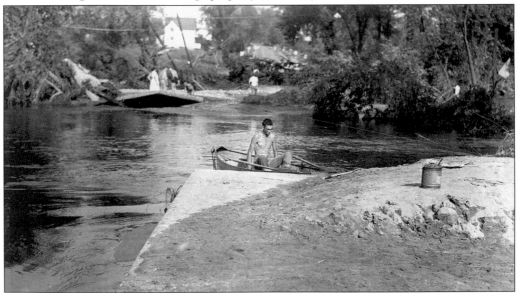

The 1955 flood was unique in that it affected high areas as well as low areas. Boston Road had large gaps in its pavement, and this picture shows a ferry that was setup to get from one part of the road to the other. (Courtesy L. Merrick.)

Four

SCHOOLS

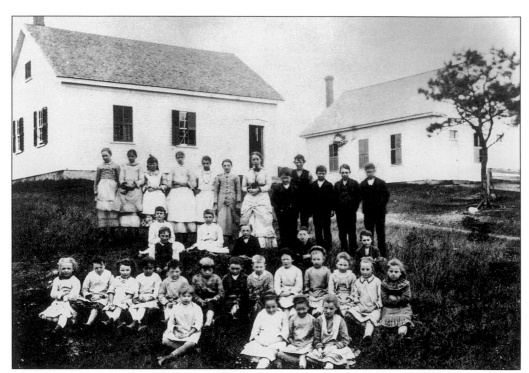

This image shows the East Wilbraham Methodist Church on the right and the No. 6 school on the left. You can tell from the differing ages of the schoolchildren that this was a one-room school. Note the age of the teacher and the size of the classes she taught. (Courtesy L. Merrick.)

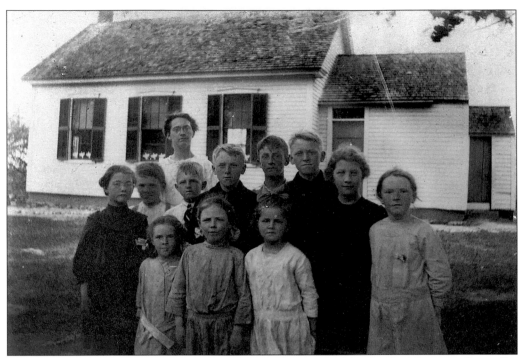

Here is another one-room school and schoolchildren with their teacher. It is much smaller group and an older teacher. These schools were set in various areas of the town, which allowed the different neighborhoods to teach the children living within them.

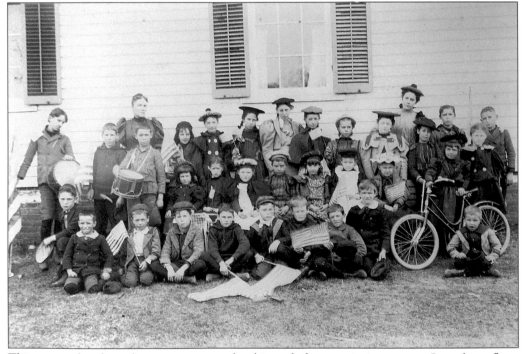

This group of students from a one-room school is ready for a patriotic program. Some have flags, while two have drums. Note the bicycle one of the girls is holding.

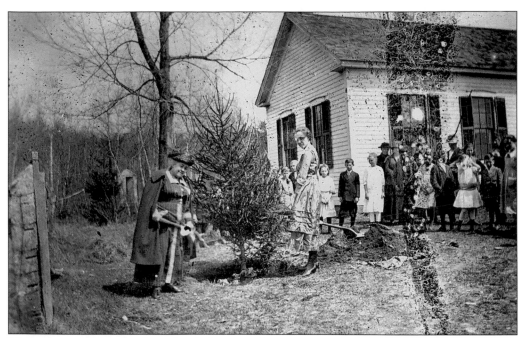

This photograph shows the official planting of a victory tree following World War I. All the children are standing watching as the adults do the planting. There were many ceremonies like this after the war. People were very patriotic and proud of their heritage.

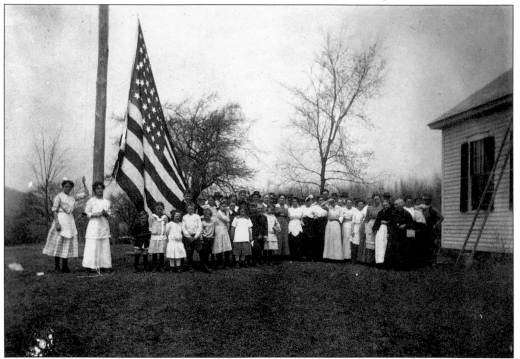

Here is an official flag raising at the Glendale School. It looks like there are many adults attending this event, so it must have been for a special occasion. Note the size of the flag and what appears to be costumes being worn.

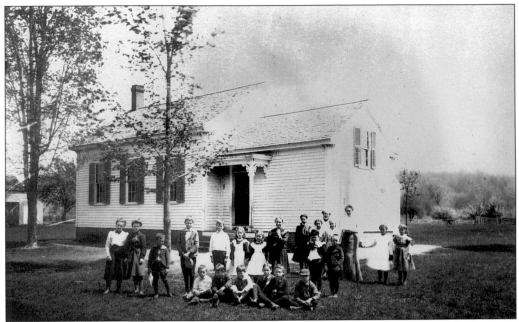

This is the No. 3 school, located at the corner of Tinkham Road and Main Street. Once again, we see a one-room school, as evidenced by the schoolchildren's ages. This building has been used by a variety of occupants. It was a teen drop-in center and an American Legion hall for many years.

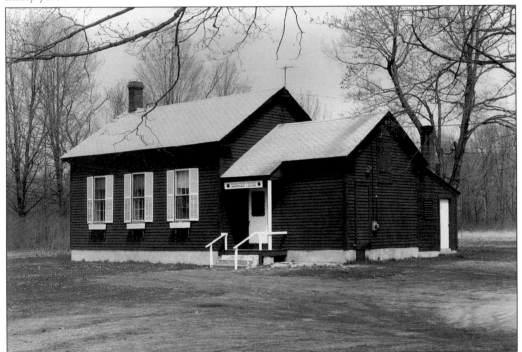

This newer photograph shows the school as the American Legion hall. It was used in this capacity for a number of years until the group moved to another building. It is now the Wilbraham Children's Museum and is very active. (Courtesy L. Merrick.)

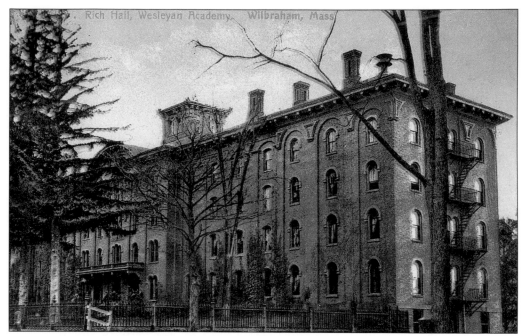

This image shows Rich Hall, the large academy building on Main Street. It houses the administrative offices on the first floor and is a dormitory on the three upper floors. The picture was taken while it was still Wesleyan Academy and had the original doorway. Note the iron fence surrounding the building. This was taken down during a scrap-metal drive during the war. (Courtesy Academy Archives.)

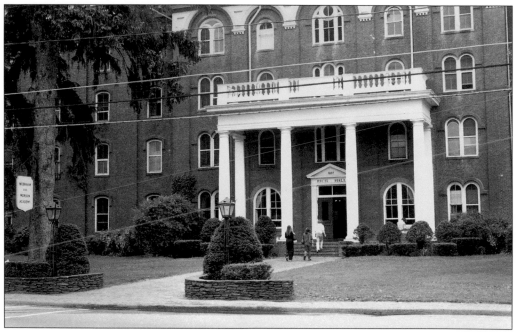

Rich Hall underwent a facade change in the 1930s. Large white pillars were added, giving a dignity to the building. This photograph shows the building as it appears today. (Courtesy Academy Archives.)

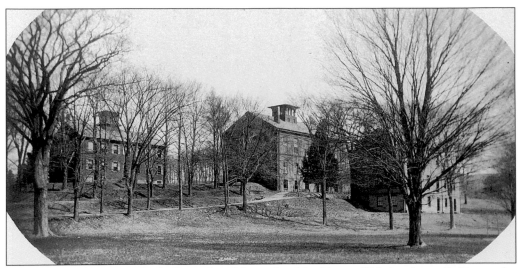

The three buildings on the hill are the oldest school buildings. Old Academy (left) was the original building—it housed the students, had a chapel, classrooms, and punishment areas. There were two doorways—one on the south for the ladies to enter and one on the north for the gentlemen to enter. Although the students shared classes, they sat on opposite sides of the classroom. In Fisk Hall, there are classrooms on the first floor. A chapel and theater are on the second floor. The new chapel gave Old Academy more space, as the students used the new one once the building was erected. The third building on the right is Binney Hall, named after a trustee. This was the science building when first built but is now used as an art building. (Courtesy Academy Archives.)

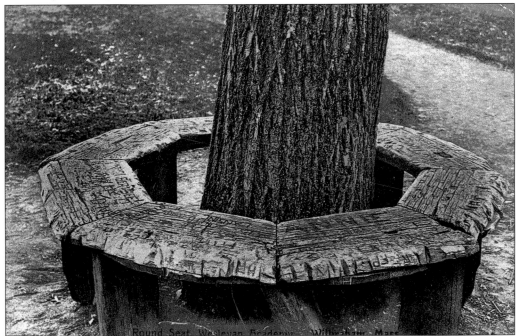

This round seat circled the tree across Main Street from Rich Hall. As you can see, the students left their mark on it. It was used to wait for transportation and friends and as a gathering spot. (Courtesy Academy Archives.)

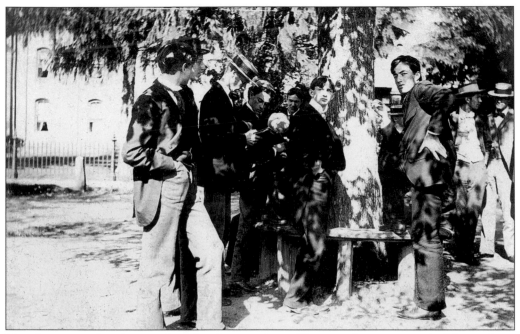

Here is a group of students gathered at the round seat. The straw hats on several of the students indicate that it was warm weather. (Courtesy Academy Archives.)

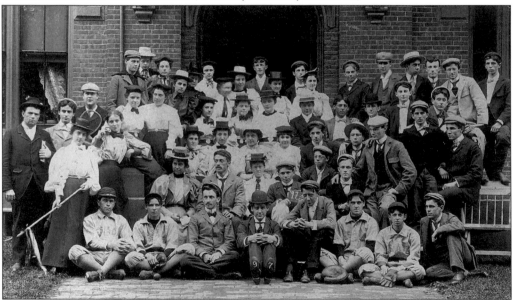

This is a class of students in front of Rich Hall. It is the Class of 1897—note the numbers on the soles of a student's shoes in the front row. Some students are in baseball uniforms, some carry tennis rackets, and some ladies are in uniforms for drill teams. It must have been time for sports after the photograph. Can you imagine having to wear clothes such as these at school? It would seem that most everyone wore hats—male and female alike. The picture was taken in front of one of the original entrances. This one leads to the south side—the women's side. Today, these doors are windows, with a doorway between to enter the building. (Courtesy Academy Archives.)

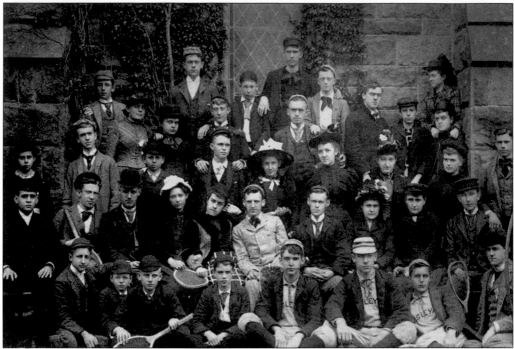

Here is the Wesleyan Academy sophomore class of 1891, shown in front of the Stone Chapel on Main Street. Notice how all wore hats, both male and female alike. There are varying ages because the class year depended upon work done, not on the calendar year. (Courtesy Academy Archives.)

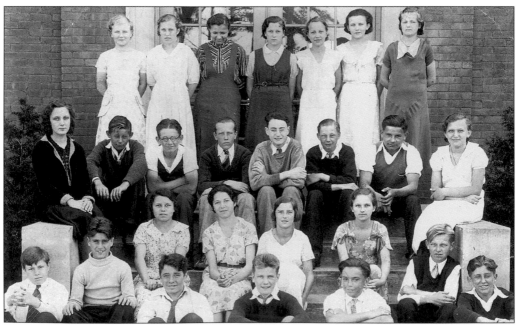

This group of students is on the front steps of the Pines School on Stony Hill Road. The clothing seems to indicate it was taken around the 1930s.

This is the picture of a woman student at Wesleyan Academy. Before the advent of yearbooks in 1913, the students gave one another a photograph and wrote in each others' autograph album. This is Gertrude Chase of North Wilbraham, who graduated in 1897. She wrote on the back of the photograph. It seems she attended for four years. (Courtesy Academy Archives.)

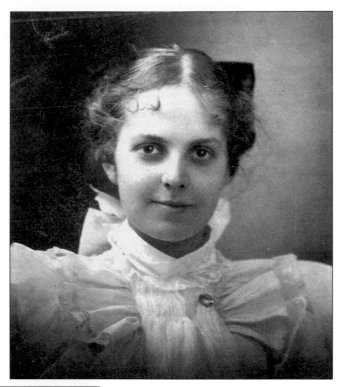

This picture of a schoolboy shows the type of clothing boys wore when dressed up. Usually, they wore the more casual clothes of a jacket, shirt, and shorts or trousers. (Courtesy M.E. MacLean.)

These tintypes of Wesleyan students show them dressed up for debating sessions. There were two debating societies—Old Club and Philo. They held club meetings monthly, where teams debated among individual club members, as well as with an opposing club. This proved very helpful to the students planning to enter the ministry or to teach. Debating became a very active part of local schools, well into the 1940s. (Courtesy Academy Archives.)

Five

TRANSPORTATION

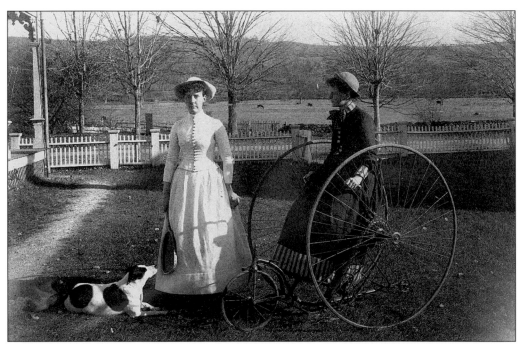

Here is an example of a different form of transportation—the first tricycle in town. It is ridden by Mabel Welch, who lived on Main Street with Mary Howard standing by. This picture was taken at the Howard home (the parsonage) front yard and looks toward cattle in the field across the street. Mabel Welch became an artist famous for her miniatures on ivory, and Mary Howard was the daughter of the minister. (Courtesy L. Merrick.)

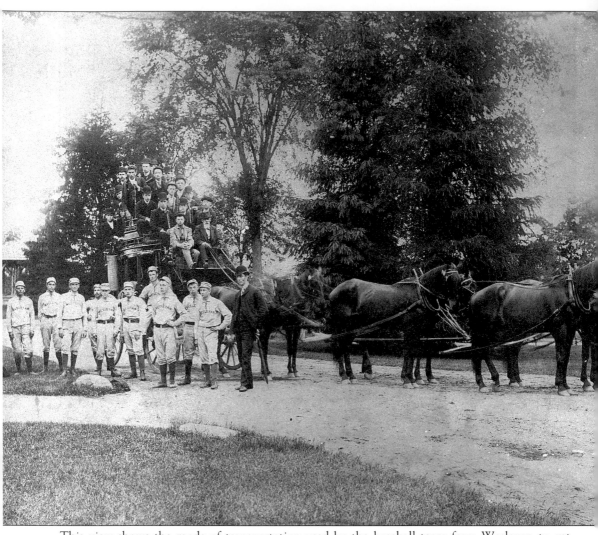

This view shows the mode of transportation used by the baseball team from Wesleyan to get to away games. This game was at Massachusetts Aggie College, which is now the University of Massachusetts. Can you imagine traveling up and over the mountains in a six-horse hitch, swaying and barreling up and down the hillside? The original stagecoaches came through from Boston on their way to Hartford and then to Springfield. The original route was along the top of the mountain on Ridge Road, later changing to the lower roads. (Courtesy Academy Archives.)

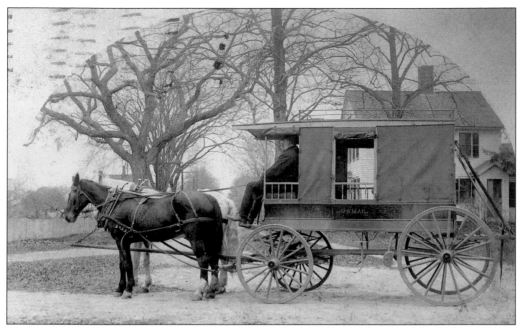

Here is a type of stagecoach used in later years—1909. This one, however, looks more like a wagon than a coach. Stagecoaches met all the trains in North Wilbraham and transported students and individuals alike to the center of the town. (Courtesy L. Merrick.)

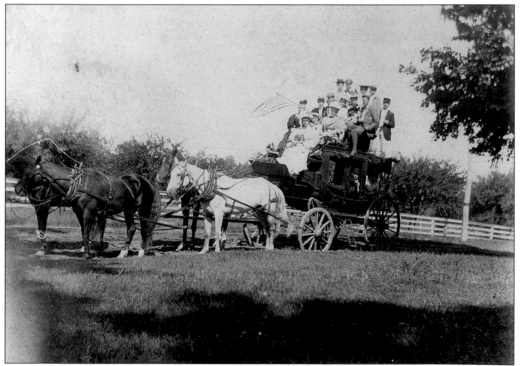

When the stage met the trains in North Wilbraham, this is the way it would be loaded with Wesleyan students for the trip to the center. It is a wonder it did not tip over, as it looks very top-heavy.

Trolley cars came to Wilbraham from Palmer and Brimfield to the east and from Springfield to the west. The trolley from town traveled over Boston Road, Old Boston Road, to the Ludlow Bridge. The passenger then transferred to a Springfield trolley to travel into the city of Springfield. The cost of the entire trip was 5¢. This image shows the trolley at the stop where the fire station is now, and on the right is the end of the railroad depot. With the advent of the trolley, all people were able to take advantage of cultural opportunities in Springfield.

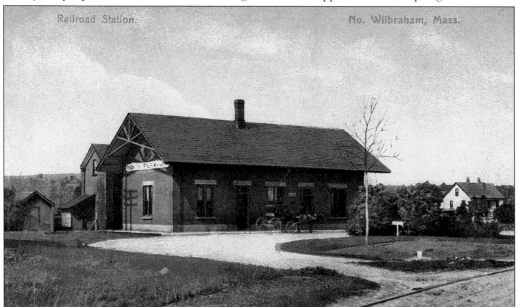

Railroad Station. No. Wilbraham, Mass.

This is the way the North Wilbraham depot appeared for many years. It was in continuous operation for more than 100 years until its closing in 1958. It was probably one of the rail company's earliest brick structures and, at the time of its closing, it was reported to be the oldest brick depot of the Boston & Albany system still standing and in use. It stood where the car wash/gas station is in North Wilbraham, just before the underpass. (Courtesy L. Merrick.)

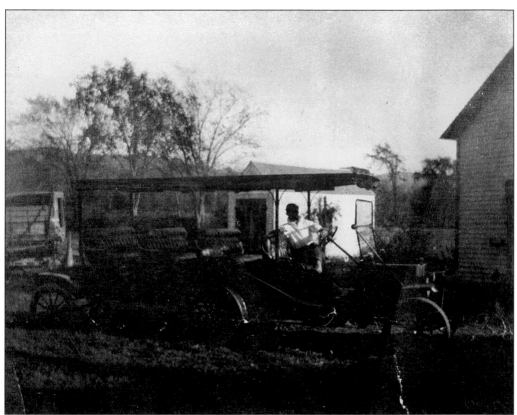

Here is a unique mode of transportation—a six-wheel jitney used by Fred Greens Livery and Stage for a time. He was the stage driver between the center and North Wilbraham. There were isinglass shades that rolled down when there was inclement weather. It was made by the Ford Motor Company. The picture above shows the driver Cleon Smith. The rendering below shows its very different construction clearer. (Courtesy L. Merrick.)

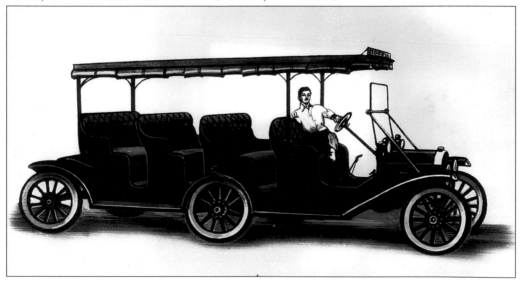

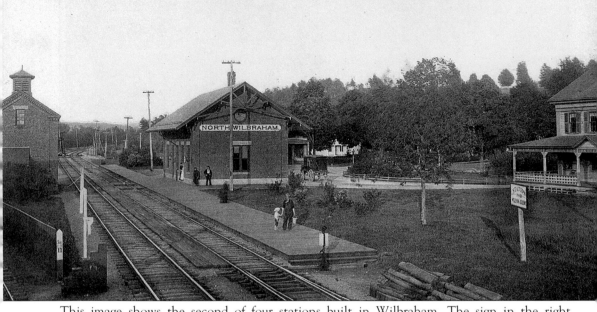

This image shows the second of four stations built in Wilbraham. The sign in the right foreground reads, "Station for Wesleyan Academy." There are two stages waiting for passengers and people waiting for the train's arrival. The depot complex was much more extensive than it became in later years. It had a freight house adjacent to the depot, gardens, and landscaping, next to a house used by the railroad, and was on the north side of the tracks. Later, the depot was located on the south side of the tracks, and the other building disappeared. (Courtesy Academy Archives.)

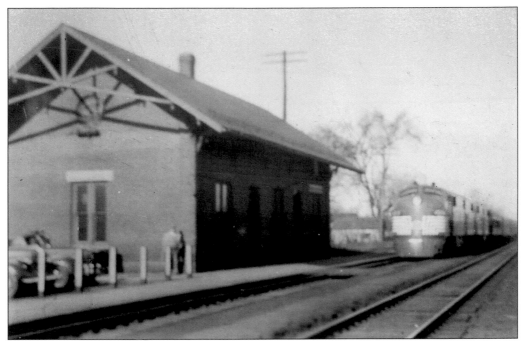

Shown here is the first diesel train to go through North Wilbraham. Before this, the trains were steam trains, which required coal and water to be replaced at stops along the route. It was quite an event at the time when the trains became diesel powered. Nowadays, once you go past New Haven, the engines are electric, so the train can enter the tunnels at New York.

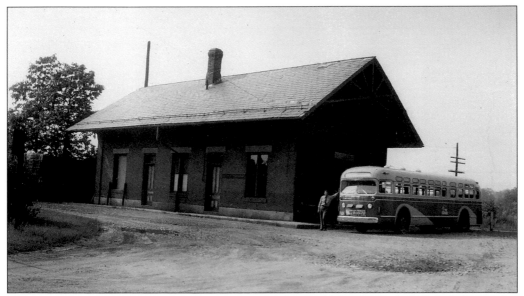

This view shows the depot in 1955 just after the flood and the Springfield-Palmer bus cutoff from its route by the washout on Route 20 at Twelve Mile Brook. This is the Sunday of August 21, 1955, with bus No. 391 having to lay over 50 minutes before bus driver Ken Chapin can resume the schedule returning to Springfield. The bus lines from Springfield made getting into Springfield or Palmer easier for all. Many working people used the buses to get to work.

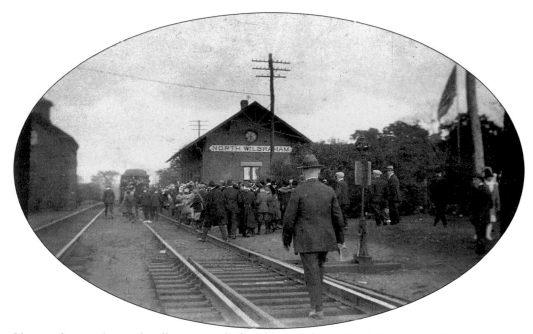

Here is the usual crowd milling around after the train has unloaded and is heading to its next destination. There were people there to pick up those arriving, or just to watch the arrival or departure, students coming in to school, and gathering of parcels.

This photograph shows what took the place of the depot when it was finally taken down. How sad, though with the advent of automobiles, gas stations did become important too.

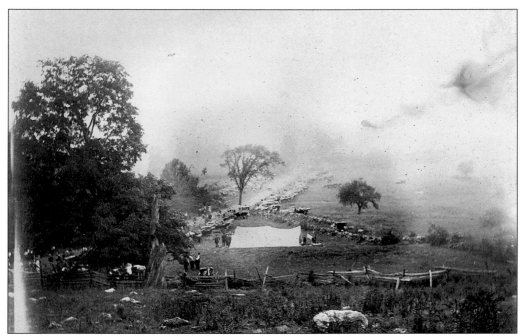

In 1908, the Springfield Auto Club sponsored a hill climb in Wilbraham on Monson Road. There were 800 automobiles with 5,000 to 6,000 spectators. It was a mile course used to test the automobiles on a dirt road and was quite steep. The winning times were for the automobile, one minute and eight seconds, and for the Indian motorcycle, one minute and two-fifths of a second. The automobile club had a clubhouse on Boston Road named Sullivan's Auto Inn. It was located where Luzis is now, opposite Nine Mile Pond. It conducted business there for years before its demise.

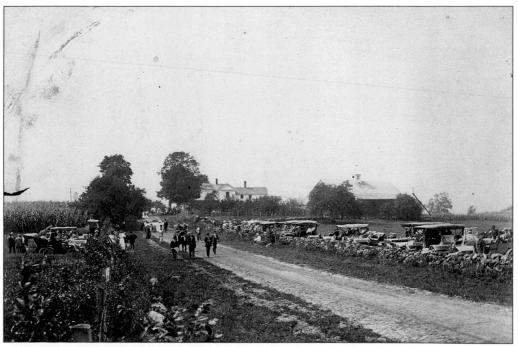

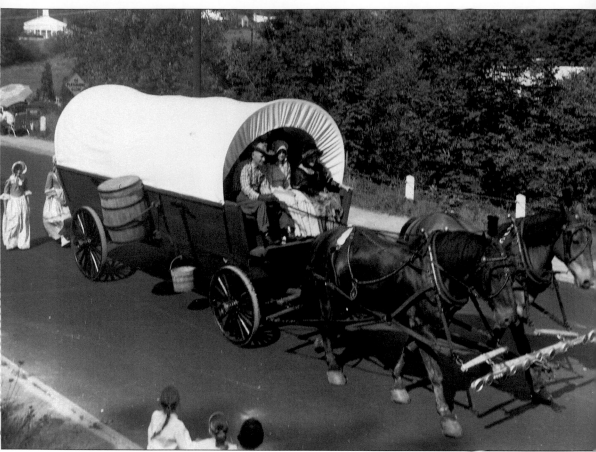

This photograph of a wagon shows the type of transportation the first settlers in the town used—especially for farming. It was not until later years that most people could afford a horse and buggy. (Courtesy L. Merrick.)

Six

BUSINESSES

Businesses were both stationary and moving. This view shows the Howlett store in Hampden and its meat wagon that delivered in Wilbraham as well as in Hampden. Many stores went to individual homes, took orders in the morning, and returned in the afternoon delivering the order. This was continued into the 1940s, as most homes had only one automobile, which the man of the house took to work, and during the World War II gas rationing that made trips to the store infrequent. (Courtesy L. Merrick.)

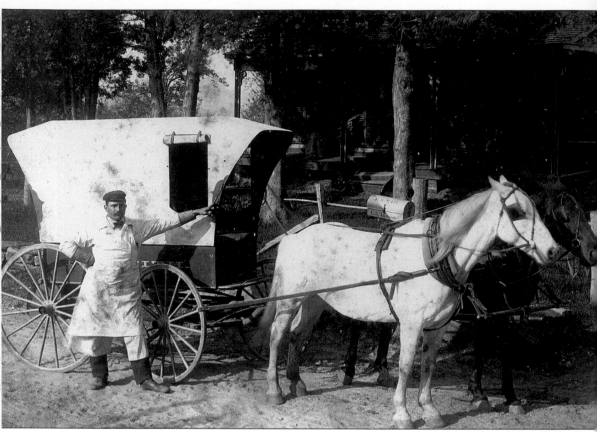

Here is the Howlett Meat Cart on its delivery route in Wilbraham. There seems to have been enough business, especially within the south end of town, to warrant these two stores to continue with their service.

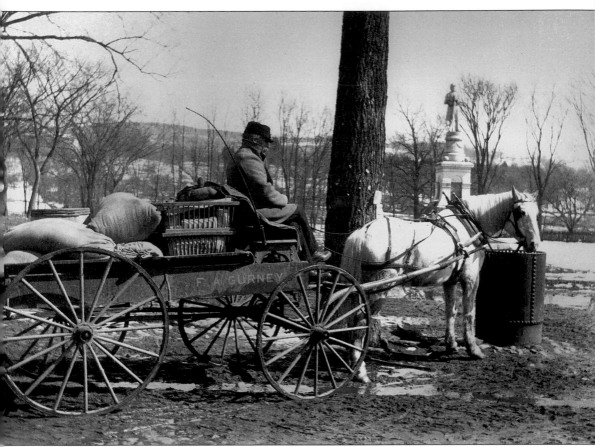

A delivery cart from the Gurney store is shown on its way to 16 Acres as the horse takes drink at the center trough. The territory that most stores covered could be extensive, but with families usually having only one vehicle for transportation, the delivery wagons were a must. (Courtesy L. Merrick.)

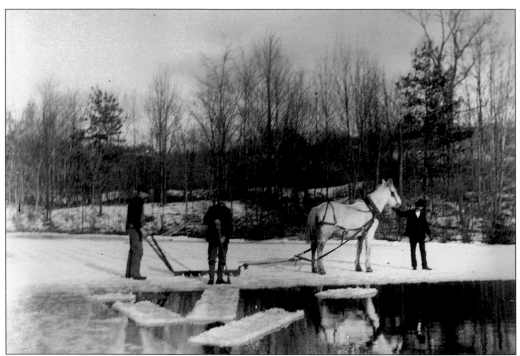

Since there were no refrigerators in the early days, there was quite a demand for ice and for iceboxes. This photograph shows ice being cut at Nine Mile Pond using a horse and saw. It was stored in icehouses with sawdust to insulate it and to hold it until delivered.

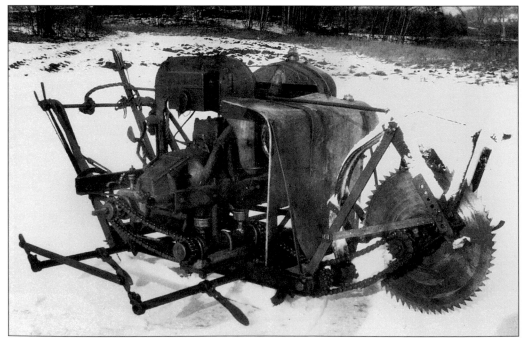

The motorized ice saw came along later and made the operation easier. The children at the houses waited for the iceman to come, as he always gave them chunks to suck on. The woman of the house would put a chart in her window showing how much ice was needed that day.

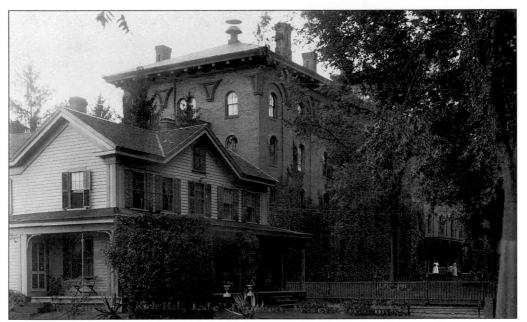

Mowry's store was in a large house next to Rich Hall, where the Main Street parking lot is now. It had extensive decorative gardens, an orchard beside and behind it, and outbuildings. The house was also lived in by the family while conducting business as a store.

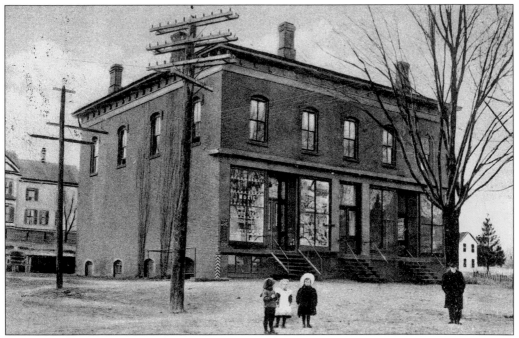

This is the brick building on Boston Road just before the underpass. It was the Eagan store for some years. The Collins Manufacturing Company built this, the first brick business building in town, which is still used for a variety of businesses.

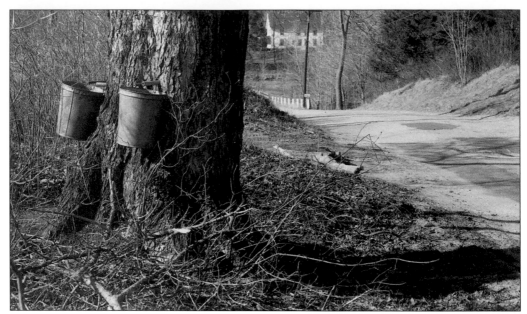

Many people tapped maple trees and made maple syrup not only for themselves but to sell. It was sold to individuals or to commercial operations for processing. This view shows some tree tapping at the top of Crane Hill Road in the Glendale area. There are individuals who still tap their trees and enjoy their own maple syrup. The local farms sell their maple syrup as well. One can see the whole operation at the maple syrup wagon, located at the edge of the Rice parking lot. While at the farm during apple season, you can watch the making of cider before making your purchases. The local schoolchildren come for tours every year.

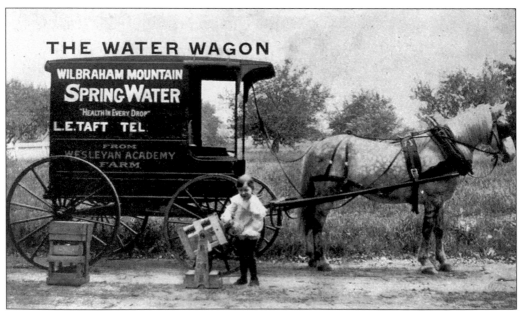

Shown here is the short-lived water company on the side of the mountain at the upper reservoir on Mountain Road. It had been in private operation, but when it did not do well, it was given to the school to run. It was a losing proposition and soon discontinued. (Courtesy L. Merrick.)

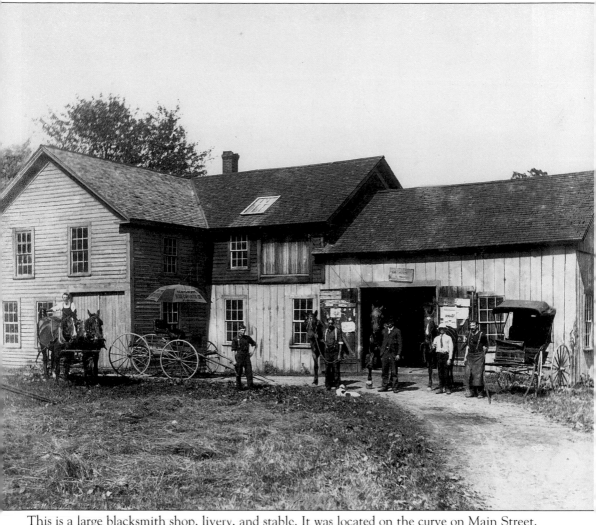

This is a large blacksmith shop, livery, and stable. It was located on the curve on Main Street, where the Berselli garage use to be. Owned by the Gebeau (Gebo) family, it eventually changed into Gebeau's Garage before selling to Berselli. Theodore Gebeau is the gentleman on the right wearing the leather apron. Salesmen who came to town could come here and rent a horse and buggy to conduct their business around town, families could hire larger vehicles when needed, and all could have their vehicles repaired here. If you only needed a horse that could be provided as well, and many carriages were made to order. (Courtesy L. Merrick.)

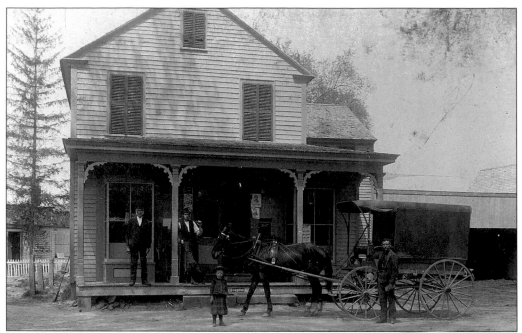

Shown here is the Old Corner Store, located on the northwest corner of Springfield and Main Streets. The Newton Lodge Masonic Hall was on the second floor. In later years, there was a post office in the building, and the Masonic Hall continued to be used for many years. Frank Gurney ran this store before buying the larger one across the street in 1908. (Courtesy L. Merrick.)

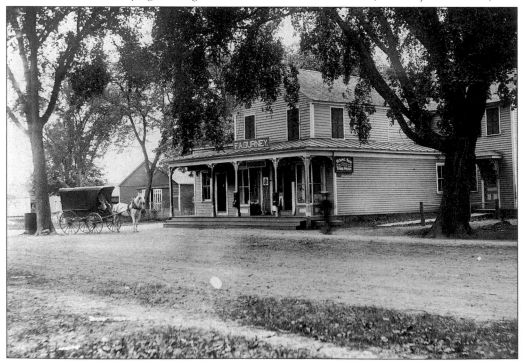

Another view of the Old Corner Store shows the delivery wagon out front and the barn in the rear. (Courtesy L. Merrick.)

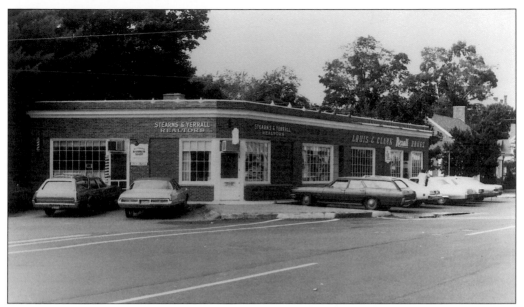

This photograph shows what replaced the post office and Masonic Hall. It was torn down and replaced with this block by Walter Salustri in 1958. The operation has since been bought by Louis & Clark Drugs, which is still in operation today. (Courtesy L. Merrick.)

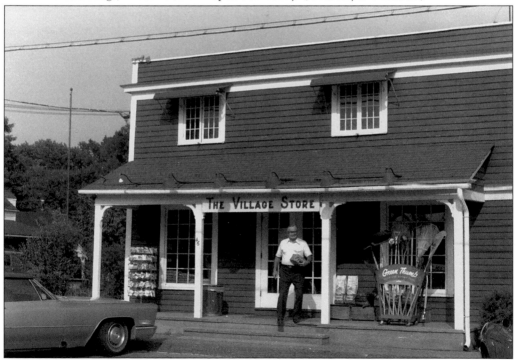

This is the Village Store, located on the northeast side of Crane Park on Main Street. Charles M. Pease built the structure in 1888. He moved a small cobbler's shop to the rear, where the Tousignant house is now, and built the store in its place. When Frank Gurney bought the store, he added the ell on the back, making it the shape it is today. It has been the oldest business in town in continuous operation. (Courtesy L. Merrick.)

This view on Main Street looks north from Crane Park toward the Village Store. The store has just undergone renovations and is awaiting new occupants.

This view of Main Street looking south shows both the Village Store on the left and the Old Corner Store on the right. Crane Park has not yet been set up, so the space is merely a field. Note how the street is divided and goes around the trees on both sides.

The view looking west down the mountain was, and still is, one that is quite beautiful. Paintings have been done, photographs taken, and the view enjoyed everyday by those living on the mountain. You can see the Congregational church spire to the left, the large stone church, and, farther to the right, Rich Hall.

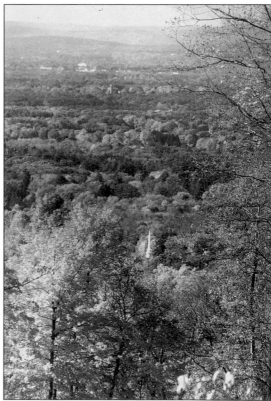

Here is a more recent view looking west from the mountain—again the church spire is just above the trees. The foliage has grown considerably since the other view. (Courtesy J. Trombley.)

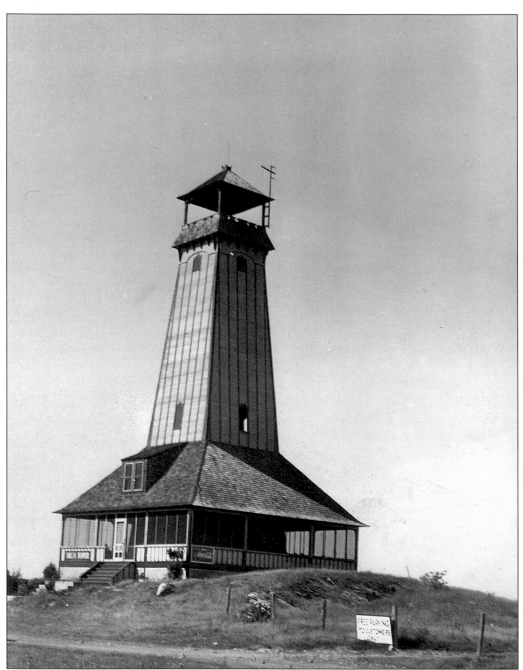

There was a lookout tower built on the mountain near the corner of Ridge and Monson Roads by John Poteri. It was 80 feet tall with a restaurant at the base. The view from the top was most impressive; you could see for 60 miles to the Dome in Hartford, buildings in Springfield, the Mount Tom and Holyoke ranges, Westover Field, Brimfield, and Worcester. Many initials were carved on the top observation platform. Sadly, the tower burned in the 1950s due to an electrical overload while shortwave radios were conducting tests. The fire was spectacular and could be seen for miles around. All that is left to remind one of it is the Tower Hill Greenhouse next to the original location of the tower. (Courtesy Paul Murray.)

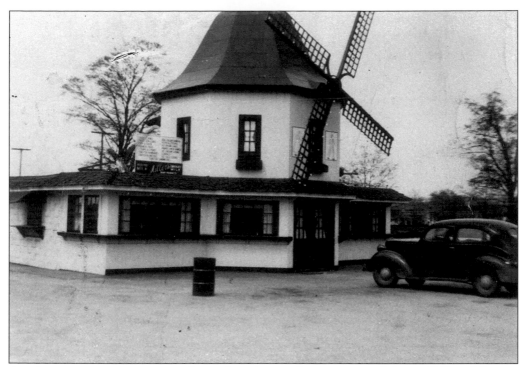

Another unique restaurant was located at the northwest corner of Stony Hill and Boston Roads. It was run by the Miller Dairy of Ludlow. The "Windmill" stood where the travel agency building is now. You could eat inside the restaurant or in your car where the roller-skating carhops took your order and delivered it to you. (Courtesy Dorothy Bednarz.)

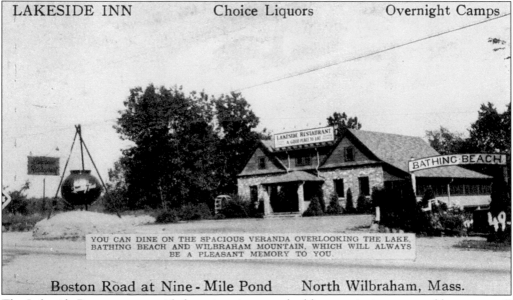

The Lakeside Restaurant provided a swimming area, bathhouse, picnic areas, and boats, as well as an indoor eating area on the veranda overlooking Nine Mile Pond or the regular dining room. The large iron kettle was a trademark for many years. People came from all around for the good food, view, and bathing. (Courtesy Paul Murray.)

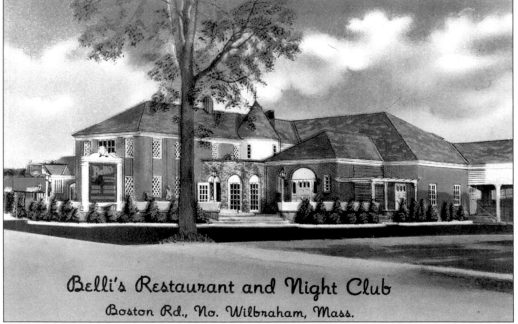

Belli's was a popular spot, especially on weekends. After many years of operation, the building has gone through a series of owners. (Courtesy L. Merrick.)

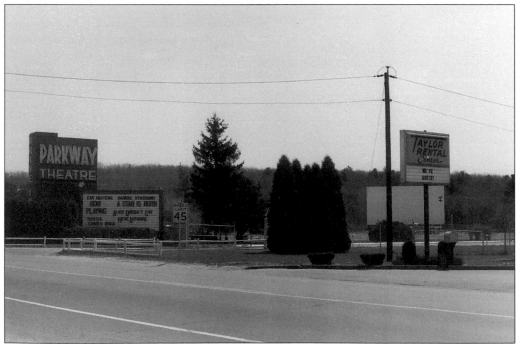

The Parkway Drive-In was a good family entertainment spot for years. When it was first built, the sound was piped into the motel rooms, as well as any house along Stony Hill Road that wished it. Families would show up with the kids in their pajamas; there was a children's play area, in-car speakers, and, later, in-car heaters. The children would go to sleep with their pillows, and parents would enjoy the film. (Courtesy L. Merrick.)

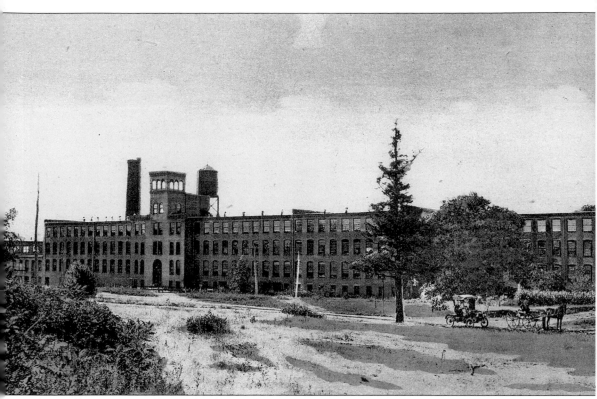

The Collins Paper Mill was the largest business in town for many years. Located in North Wilbraham on the bank of the Chicopee River, it was built in 1872. Sold to the Whiting family in 1886, it made the finest writing paper and, for a short time, government currency paper. This was the main factor for the development of the northern part of town and was in continuous operation until the 1940s. Many a time a town meeting vote was held up by a filibuster to allow the shift to get out and the workers time to get to the meeting to vote. That was when attending town meeting was fun. The mill is now mostly in use as rental space for various businesses. (Courtesy L. Merrick.)

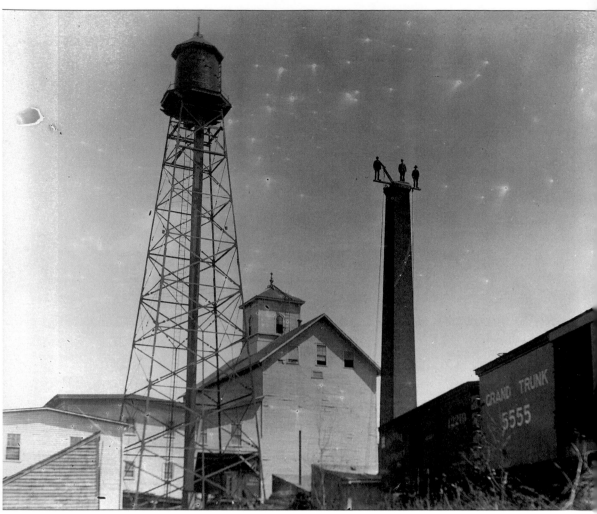

The Cutler Coal and Grain was another company along the Chicopee River that relied on waterpower and the railroad. It was started in 1844 by Henry Cutler and moved to Wilbraham in 1877. After Quabbin reservoir lowered the height and volume of the Chicopee River in the 1930s and the Hurricane of 1938 washed away the turbine, it was sold. The new owner moved in 1952 to Palmer. Note the men standing on the smokestack. (Courtesy L. Merrick.)

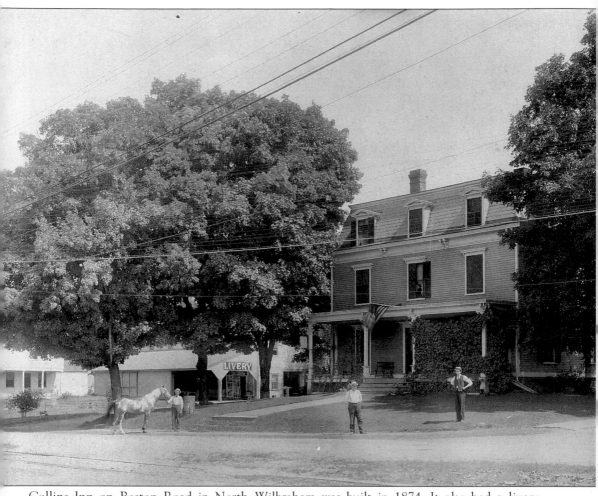

Collins Inn on Boston Road in North Wilbraham was built in 1874. It also had a livery stable. The Central Telephone Station was located here when first established. It became the telephone office in 1914 and was used as such until the dial system was installed in 1952. The system used, with operators, were the crank phones. Many times the operators could tell you where the emergencies were, how long the lights would be out, transfer calls when you went to someone else's house, and gave you a message from a family member. (Courtesy L. Merrick.)

Here is the living sign for Friendly Ice Cream that is visible from the turnpike. It is just before you come to the Ludlow exit, when heading west, and is located just west of the East Wilbraham Cemetery. (Courtesy L. Merrick.)

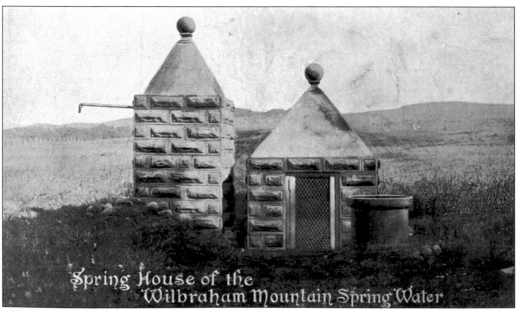

Spring House of the Wilbraham Mountain Spring Water

This spring house on the mountain was used for an unproductive water company. (Courtesy L. Merrick.)

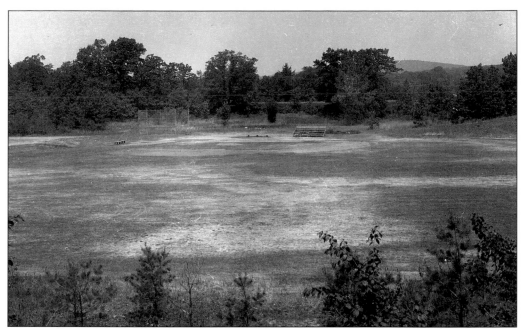

One of the best sport areas in town, Grassy Hollow on Boston Road, was given by the Collins Mill to the town. For many years, this spot was busy with its several baseball diamonds in use. The town even had a championship team in 1925 in the Quaboag Valley League. (Courtesy L. Merrick.)

In 1976, Grassy Hollow was taken over by the town to be used as a town dump and landfill area. The town now has a lovely Mount Trashmore as a result. This picture shows the start of the transition from playing fields to dump.

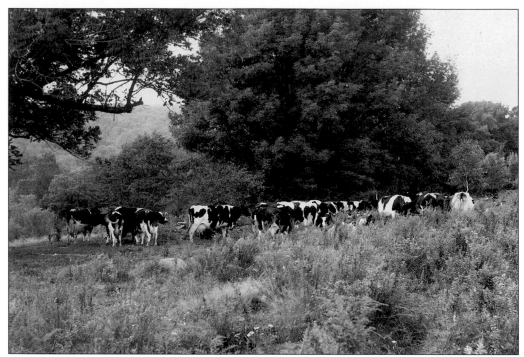

The herd in the field has been replaced by the town community gardens. People of the town are able to pay a nominal fee for a section of the field to grow whatever they desire—vegetables, flowers, or both. (Courtesy L. Merrick.)

Every year, the sections are sold-out, as residents enjoy their gardening. It is located on Monson Road, just east of Glendale Road and adjacent to conservation land.

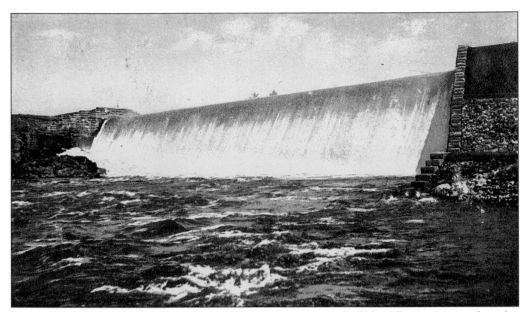

Here is Red Bridge Dam in the North Wilbraham section called the Elbows. It is at the edge of the Chicopee River and, to this day, still provides hydroelectric power. This area is a particularly beautiful one for boating and fishing. (Courtesy P. Murray.)

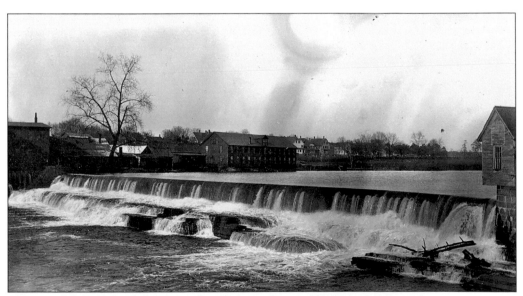

This is another of the dams along the Chicopee River. (Courtesy P. Murray.)

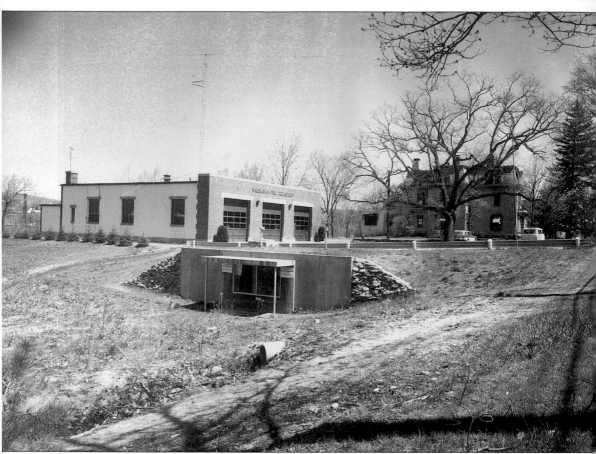

In 1958, a model underground radiological fallout shelter was constructed by the town civil defense group on Boston Road near the fire station. It is in the ground just west of the fire station. At first, a great many people stopped and viewed the shelter, as there was much interest in it due to the Cold War. It was built through the assistance of the Massachusetts Civil Defense Agency at no expense to the town. Note the fire station in the background with the town library behind the tree. (Courtesy L. Merrick.)

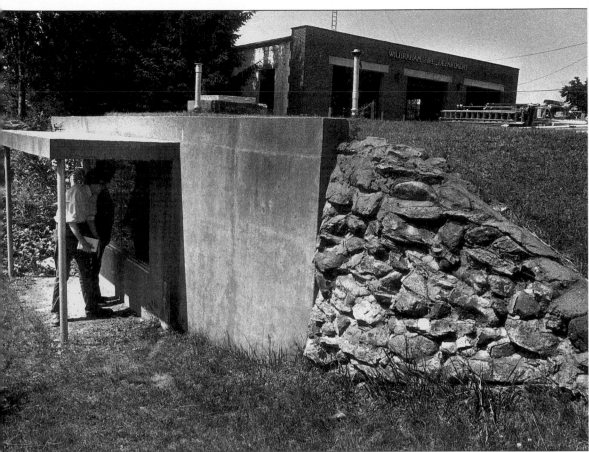

This photograph shows the viewing window, which allows people to see into the shelter, thus giving them an idea of how to set one up for themselves. Two people in town did exactly that—built personal ones at their homes.

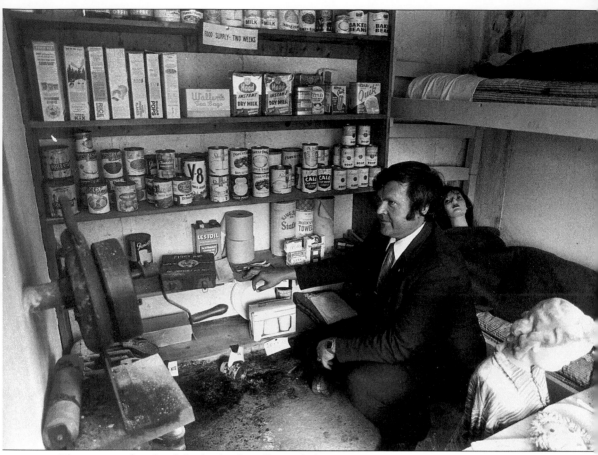

The interior has bunk beds, food stuffs on shelving, mannequins in various poses of activity, and air apparatus. This photograph shows Chief Bob MacCauley of the fire department. Over the years, the display has lost its appeal and few people view it, let alone even know of its existence.

Seven

POLICE AND FIRE
DEPARTMENTS

This is the old schoolhouse since converted into the town hall with the police in the basement area. The building was then turned into the current police station after the town offices moved into new quarters on Springfield Street. While the old town hall facilities were being converted into a police station, the little red schoolhouse on Springfield Street served for a short time as the station. (Courtesy L. Merrick.)

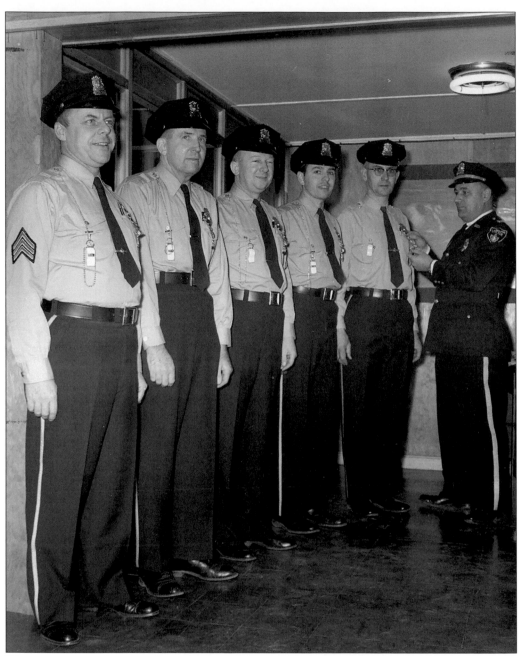

The town came a long way from the days of a constable by forming a special group to assist the state police in its evening coverage of the town and, later, by the formation of the auxiliary police in 1958. These five auxiliary policemen won revolver medals for their accuracy in shooting. Here they are receiving their medals from Sgt. John Chrzanowski, who was the group leader. Shown from left to right are Paul Fisher, Robert Fay, Wellington Rose, Art Hunt, and Newton Goewey. (Courtesy Mark Paradis, police.)

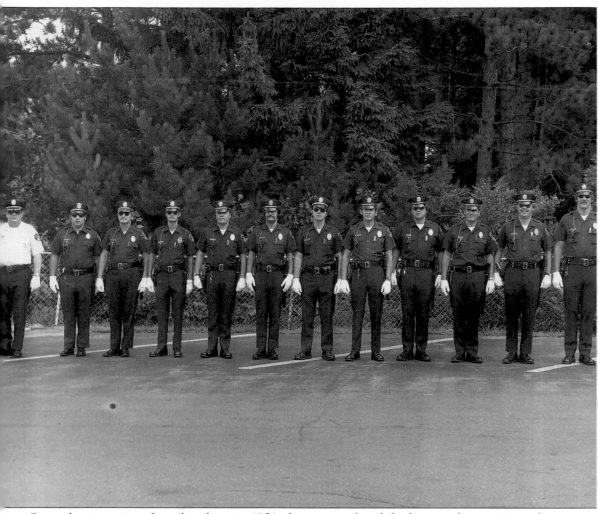

Since the inception of a police force in 1954, the town replaced the longstanding position of constable with a group of special police, auxiliary police, and, finally, a force of regular police. This photograph shows Chief Brainard at the station with the force in 1976. From left to right are Chief Brainard, Anthony Bernardes, Steve Cos, Bill Plourde, Larry Herault, Jim Arslanian, Matt Geboskie, Kenneth Konopka, Robert Sweeney, Jeff Wilcox, and Robert Pabis. (Courtesy Mark Paradis, police.)

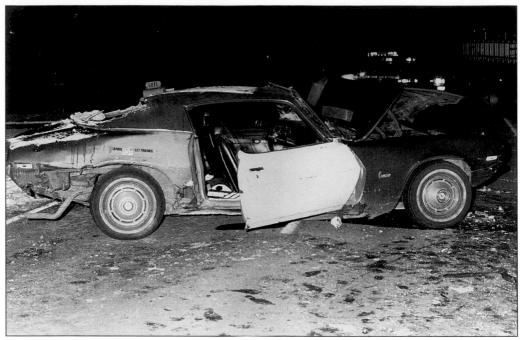

This scene of an accident shows one of the things that police have to contend with frequently. Note the decal on the rear fender and the can in the road below the door. (Courtesy Mark Paradis, police.)

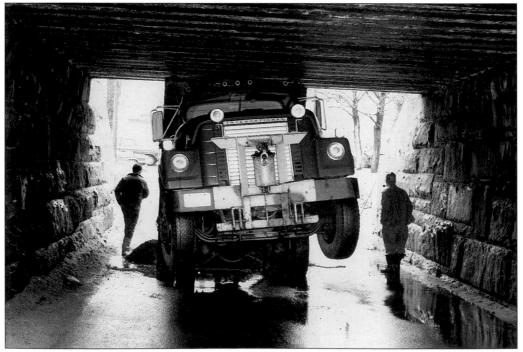

Some of the accidents responded to are a result of poor judgment. This driver certainly did not judge things accurately, as he tried to go through the Stony Hill Road underpass. (Courtesy Mark Paradis, police.)

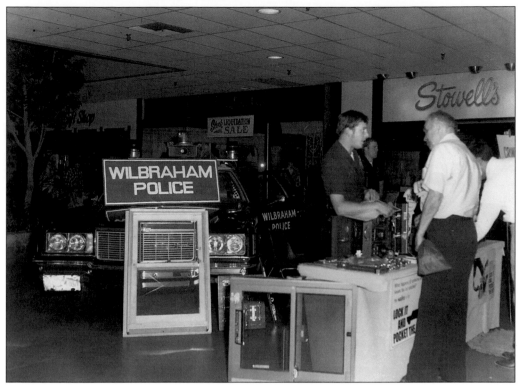

Some police work is the education of the public to safety measures and knowledge about the force. This display, set up at Eastfield Mall, stressed the need to lock doors and windows in one's home. The people got to meet and see the police from a nonthreatening aspect, which was good for the relationship between police and the public. (Courtesy Mark Paradis, police.)

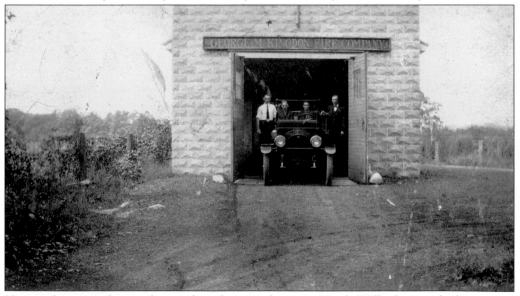

Here is the original town fire truck and station house in North Wilbraham with the original firemen. From left to right are Ed Spafford, C. Fletcher, L. Costello, and C. Backus. (Courtesy Dave Bourcier, fire.)

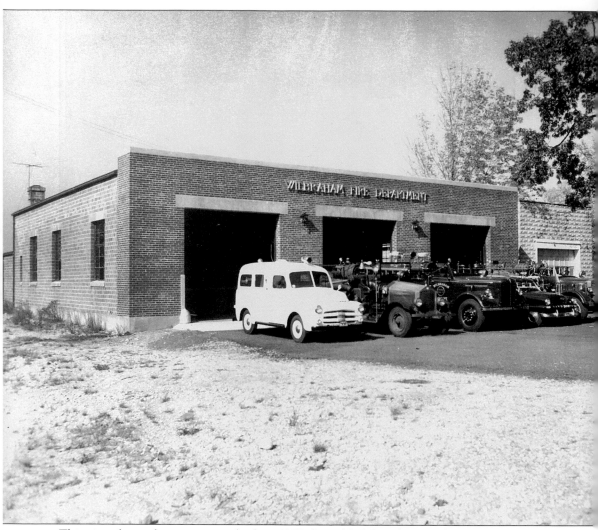

This view shows the new station built in 1952 that added three bays to the original 1919 station house, as well as a larger fleet. The vehicle on the left was the town's first ambulance, given to the town by the Grange. The personnel of the fire station were volunteers. Businessmen in the town would respond to the siren. You would see the barber, town doctor, storekeeper, garage mechanic, and others take off for the station. The first man to the station got the engine going. Youngsters soon learned the signals of the siren and, when a brush fire was indicated, they would get on their bikes and head to help. They wore backpacks and sprayed the ground fires for 25¢ an hour. (Courtesy Dave Bourcier, fire.)

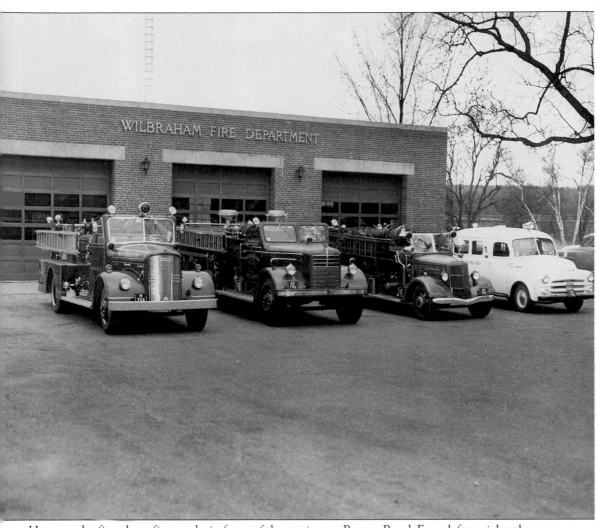

Here are the first three fire trucks in front of the station on Boston Road. From left to right, they are the 1955 Ward LaFrance, 1949 Oren, 1938 Reo, and the first ambulance, a 1952 Dodge. (Courtesy Dave Bourcier, fire.)

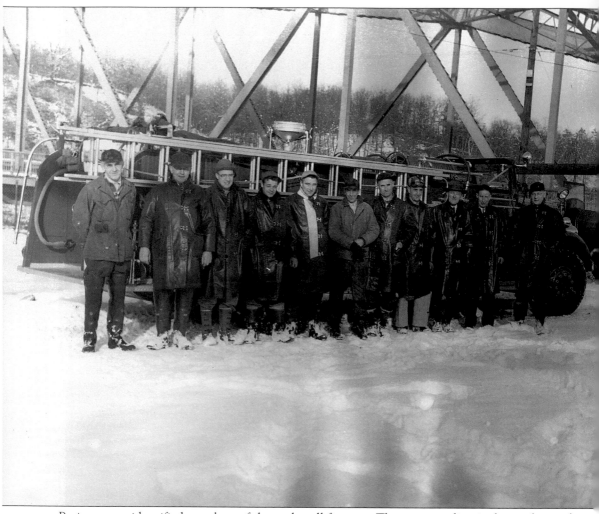

Posing are unidentified members of the early call firemen. They are standing in front of two of the earliest trucks and near the Singing Bridge. The man third from the right is Ralph Tupper, who became one of the legendary fire chiefs of the town. (Courtesy Dave Bourcier, fire.)

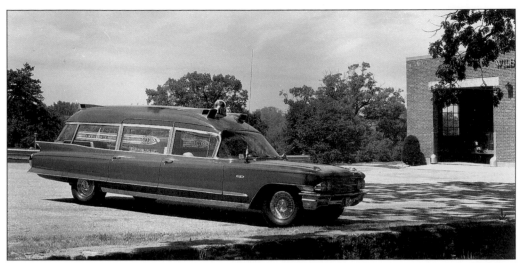

The town used the ambulance for 10 years and then purchased a newer one—a 1962 Cadillac. For a while, the ambulance service remained with the fire department, and then the town decided to discontinue that and go with an ambulance service from out of town. The town shared the service with a nearby town. For a few years, this was the fact, but the response time became delayed due to the ambulance being in the other town, in between, or on a run. The town voted to return to the service of its own fire department. All personnel are trained EMTs, with some having first responder, and there are two rescue vehicles now. (Courtesy Dave Bourcier, fire.)

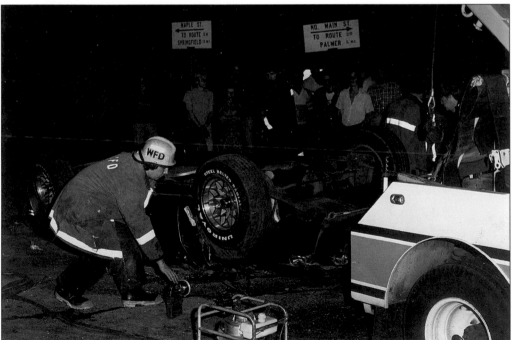

Many times, the fire and police departments serve in similar capacities. This is apparent at automobile accidents, when both services respond. This image shows an accident with the automobile overturned, being handled by the fire department and a tow truck. (Courtesy Dave Bourcier, fire.)

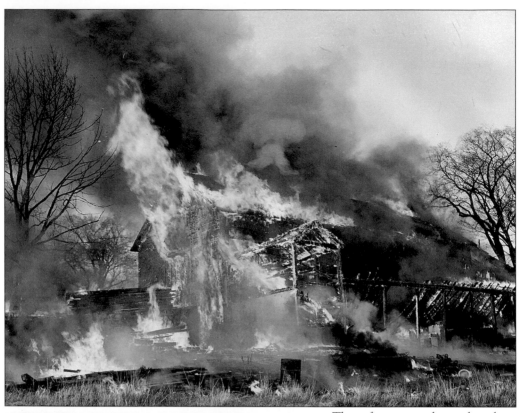

These fire scenes show what the firefighters have to contend with when they answer a call. It might be fully involved, as the house in the first picture indicates, or it could be smoldering. If it is a barn fire, as in the second picture, there is the added problem of animals. (Courtesy Dave Bourcier, fire.)

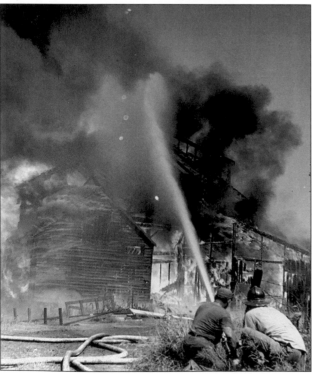

Eight

CEMETERIES

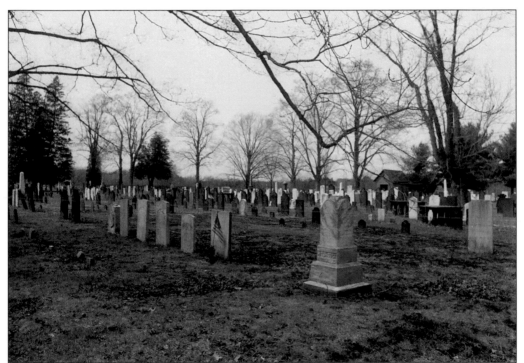

There are four cemeteries in town. Adams, Glendale, and East Wilbraham are public cemeteries, and Woodland Dell is private. Adams has some of the oldest stones, and that makes fascinating reading. Here is a view of the older stones in Adams Cemetery on Tinkham Road. This historical section has been cataloged and put into booklet form. It is arranged with a map and comments, so a person is able to walk through the cemetery and learn the history of the stones and the cemetery. There are several stones that mark the graves of the six children who drowned in Nine Mile Pond in an April 1799 sailing accident. (Courtesy L. Merrick.)

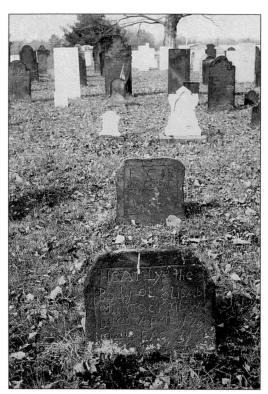

This photograph shows the grave of the first person to be buried in Adams—Elizabeth Cockril, 1741. She was visiting from out of town when she took sick and died. Until she was buried, the townspeople did not want one of theirs to be the first one buried. Directly after she was buried, townspeople began to be interred. (Courtesy L. Merrick.)

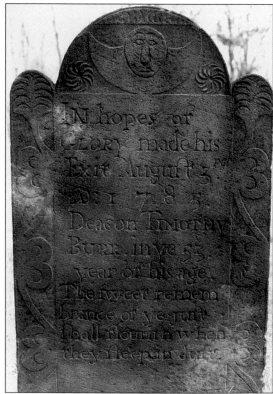

Here is another historic stone located in the East Wilbraham Cemetery—Timothy Burr, who died at age 53 in 1785. He was one of the earlier people in town.

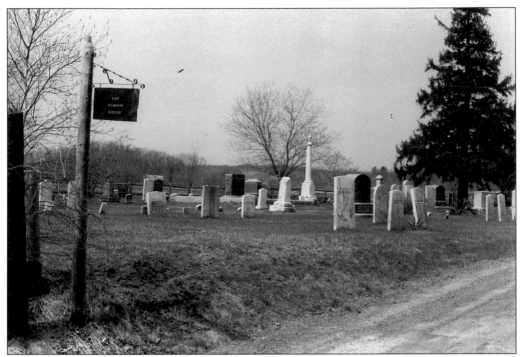

These are some of the stones found in the East Wilbraham Cemetery. With the new marker recently placed at its entrance on Boston Road, more people are visiting the historic stones and are also buying lots in an area they were unaware of.

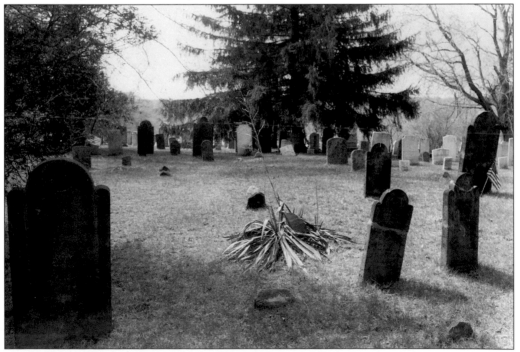

Here is a view of the stones in the Glendale Cemetery. It also has some very historic stones that are well worth reading. Every year, Flag Day services are held here.

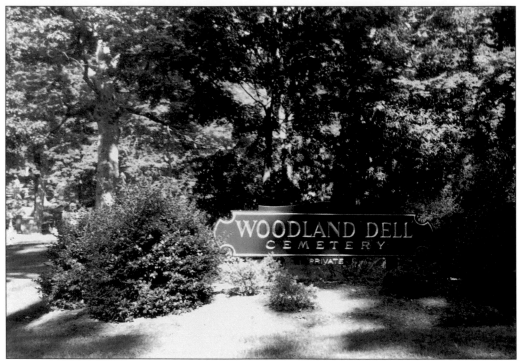

This is the entrance to Woodland Dell Cemetery, a private cemetery on the side of the mountain. There are many historic stones in this area, as well as current ones.

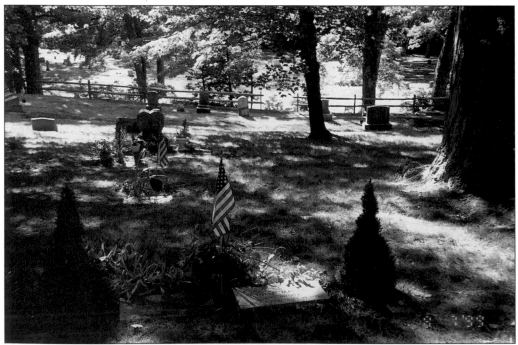

This view, looking west down the mountainside, shows all styles of stones to be found in this cemetery. Many have had to be reclaimed from the southern side, where the trees had started to take over. There is a brook running down the mountain at the edge of the property.

Nine

PARADES

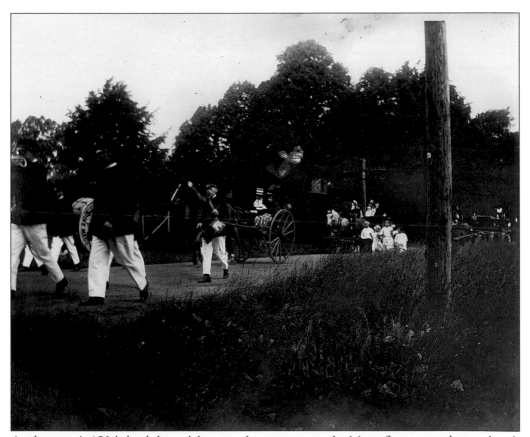

At the town's 150th birthday celebration there was a parade. Many floats were designed with wagons and buggies. This picture shows a section of the parade with a band from the town of Thorndike, a one-horse shay, and several wagons. (Courtesy L. Merrick.)

This photograph shows the former town library located on Boston Road. It is all decorated for the presentation ceremonies at the celebration in 1913. Henry Cutler deeded his home to the town in his will for use as a library. The town offices were located here as well. The library remained in use here until the present one in the center was built. (Courtesy L. Merrick.)

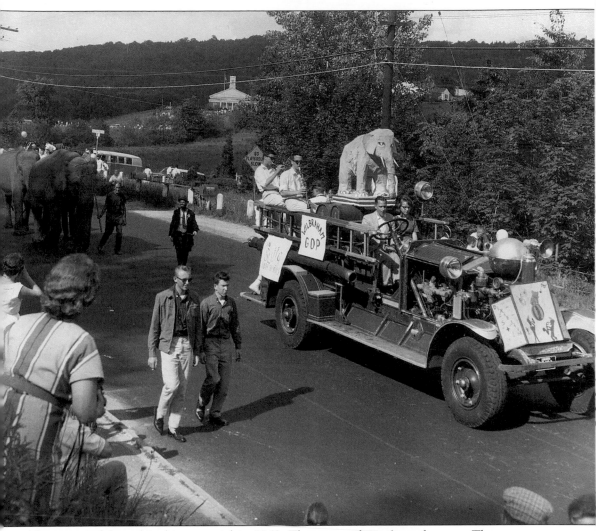

The town celebrated its bicentennial in 1963. There were three days of events. There was a great parade that went from Memorial School along Main Street to Minnechaug High School. Participating were floats from several neighboring towns, groups within the town, and marching bands from surrounding areas. One of the highlights was the appearance of two live elephants walking down Main Street. To this day, people talk about the sight of those elephants! (Courtesy L. Merrick.)

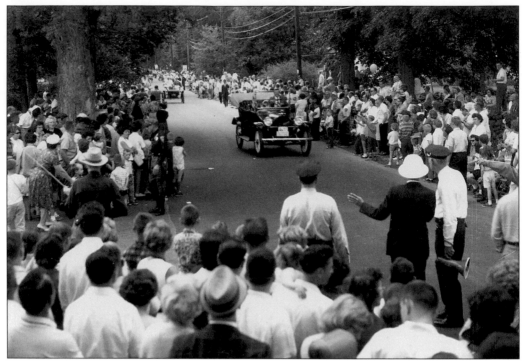

The photograph above shows the crowds lining Main Street, watching the parade. Here are some of the antique cars that participated in the parade. The shot below shows the antique cars just starting the parade route at Memorial School. (Courtesy L. Merrick.)

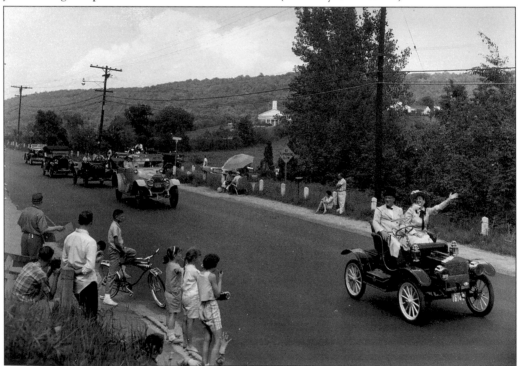

Ten

PEACHES AND
PEACH FESTIVAL

Wilbraham has been famous for its peaches for many years. In 1876, a resident decided to set out some trees in anticipation of a good crop. After one good crop, however, the trees soon died because of scant knowledge. Ethelbert Bliss tried again in 1894. In 1900, C. Beebe, C. Bolles, and J. Rice set their peaches at a higher elevation than the other orchards and had better luck. Rice was one of the biggest producers, and the quality of his peaches well established the reputation of Wilbraham peaches. The Rice family is the only one of the peach pioneers still actively engaged in growing peaches. In the days of marketing peaches out of town, there were specially constructed wagons loaded with peaches that set out at dawn for the city. However, the bulk of the peaches and apples are sold at the farm stands nowadays. People travel, in some instances, miles to get their peaches for canning, as well as eating out of hand. This picture shows a young peach tree in blossom. (Courtesy Jesse Rice.)

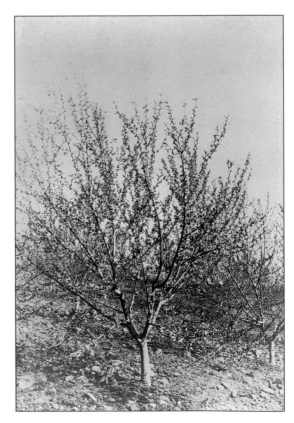

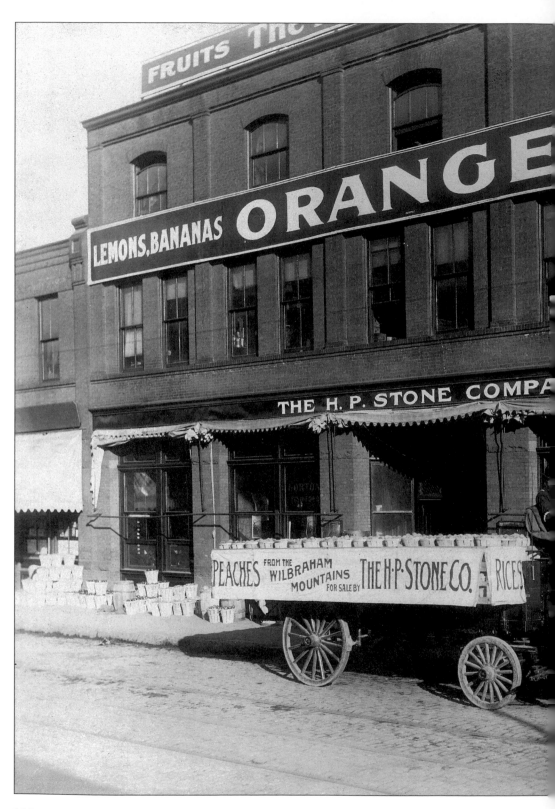

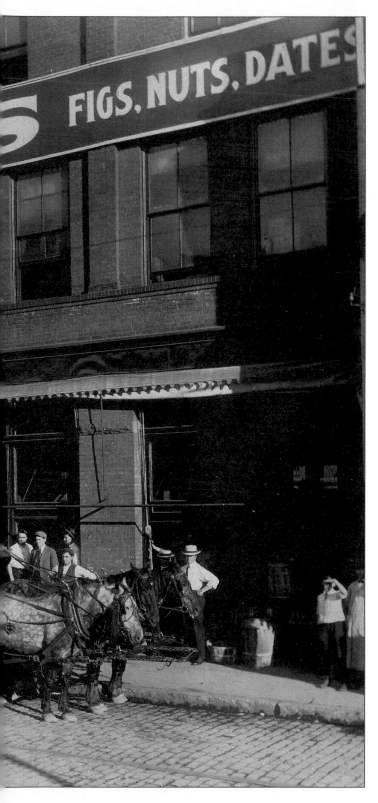

This view shows one of the specially constructed wagons used to transport the peaches to market. It has arrived at the distributor in Springfield after a slow and steady trek from the farm. Many times, smaller retailers with their wagons would follow the peach wagon into Springfield to assure themselves of the best selection. People would line up waiting for fresh Wilbraham peaches to arrive. At this time, most of the produce was sold to distributors and not at the farm. This meant that great care had to be taken to preserve the fruit on the trip to market, as seconds or bruised fruit dropped the value and was apt to create a bad reputation. (Courtesy Jesse Rice.)

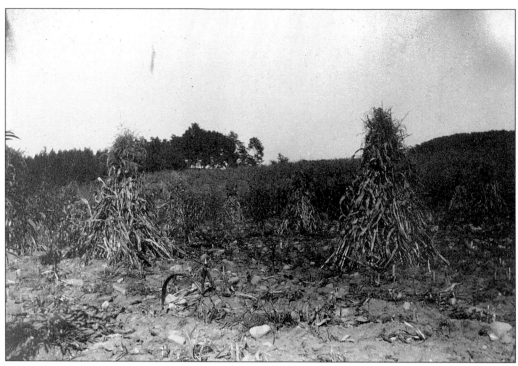

It is a year-round proposition tending the peaches—trimming trees, setting new ones out, clearing under the trees, spraying, harvesting, sorting, shipping, and selling. The shot above shows young trees set in among corn. The view below is of potatoes growing in a young orchard. (Courtesy Jesse Rice.)

Here are yearling trees in a newer section of the orchard and a winter scene of young trees. (Courtesy Jesse Rice.)

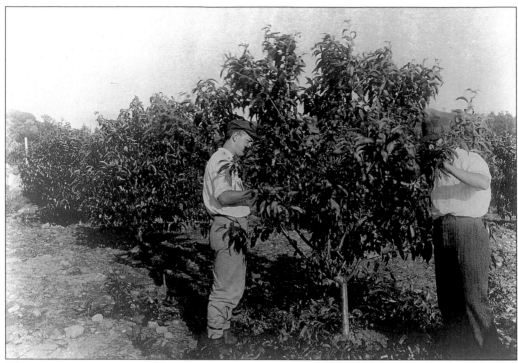

These shots show some of the work involved. These are two-year-old trees being pruned in August. The other is after the pruning has been done. Note the limbs on the ground. (Courtesy Jesse Rice.)

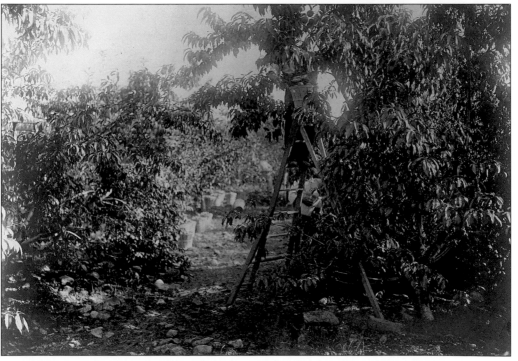

When the fruit was ready for harvesting, pickers would come to town. Most of them followed seasonal fruit harvest as their work. They would stay through the harvest and then move on to the next crops ready. Here are examples of harvesting. As a tree was picked, the ladder was moved along to the next one and the baskets of fruit were set on the ground waiting for pickup and transporting to the sorting shed. (Courtesy Jesse Rice.)

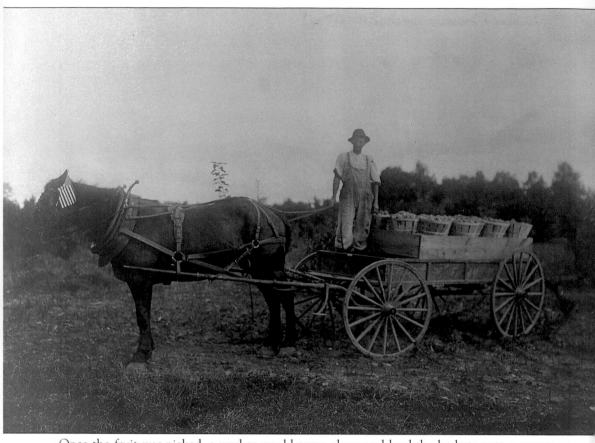

Once the fruit was picked, a worker would come along and load the baskets onto a wagon or truck and take them to the sorting and packing shed. In early days, the sorting was done in the orchard area; it was later moved to the house and barn area. The public enjoyed watching the fruit being sorted when they looked over the fruit for purchase. (Courtesy Jesse Rice.)

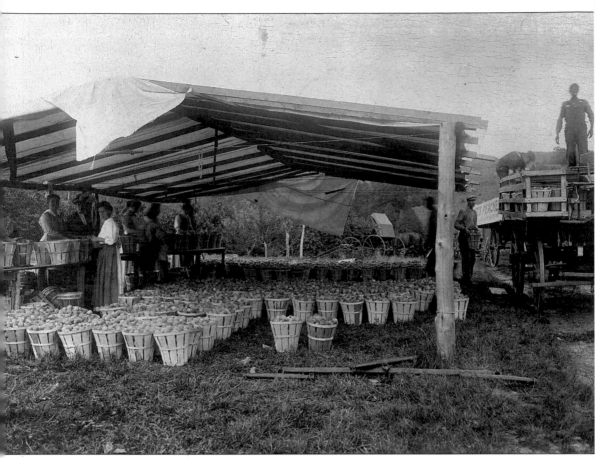

This shot shows the large sorting and packing shed up in the orchard. As you can see, most sorters were women and still are today. (Courtesy Jesse Rice.)

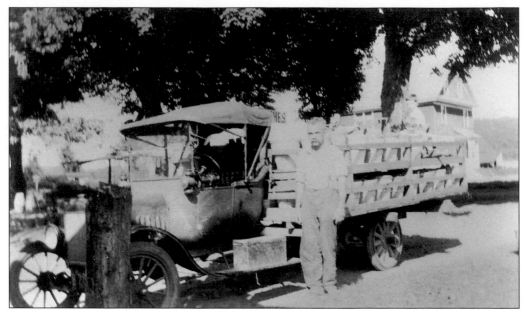

These views show a truck just arrived at the sales area and a newer picture of women sorting. The latter shows the sorting and sales area that was in front of the Rice house for years before it was moved into the large barn on the other side of the parking lot. (Courtesy Jesse Rice.)

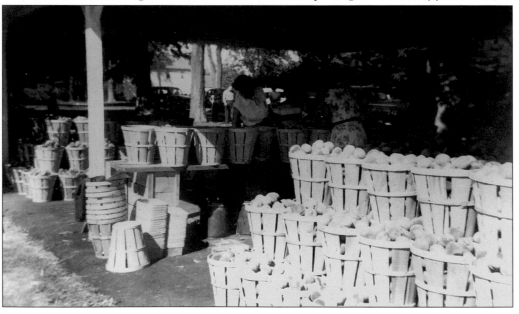

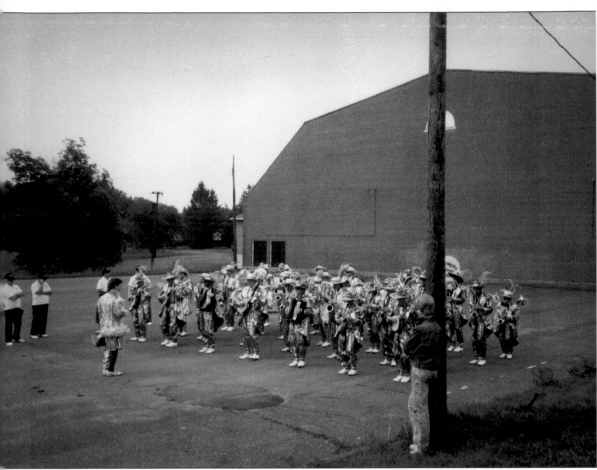

Wilbraham held town fairs for some years and then decided to put the energy into a three-day celebration of Wilbraham peaches. This is still in practice today with the Peach Festival held each August at Fountain Park (once the State Game Farm) on Tinkham Road. There is still a parade, although it is a shortened route in deference to the town merchants in the center of town. Here are the Philadelphia Mummers ready to go with their special strut!

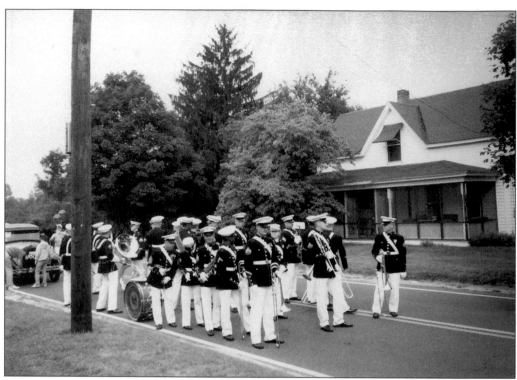

These pictures show some of the units lining up to start the parade: a Marine band ready to stride out with its great marching music and a town fire truck with Smokey the Bear.

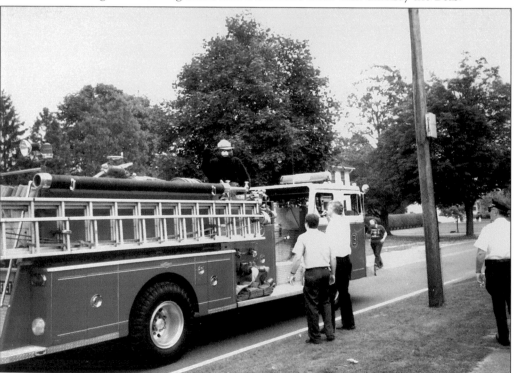

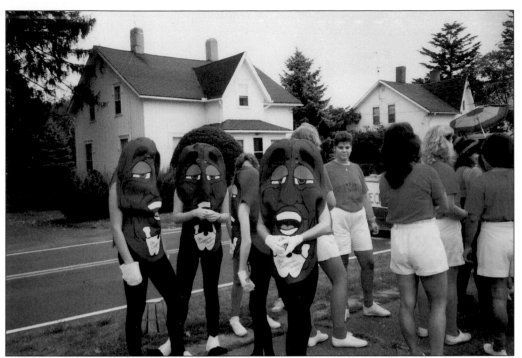

Here are the California Raisins along with a marching group and the Rice float waiting for the call to start lining up for the parade.

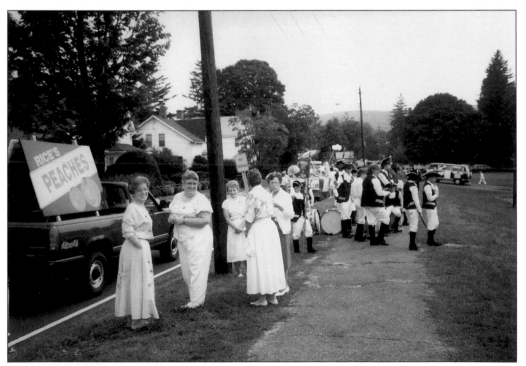

Shown is another view of the Rice contingent, with a fife-and-drum marching group in the background.

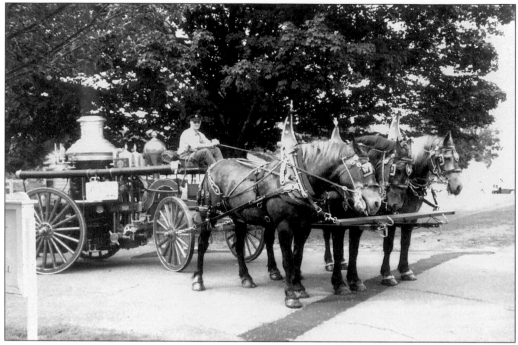

This view shows an 1895 three-horse hitch steam fire wagon. It was always a crowd pleaser with the steam coming out of the stack and the large horses pulling the wagon.

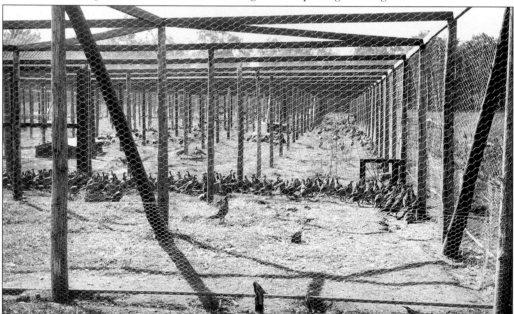

This holding pen was located at the Pheasant Farm on Tinkham Road. The farm is now called Fountain Park after Larry and Carol Fountain, who purchased it from the state and donated it to the town. Pheasant and quail were bred, hatched, and raised, totaling 28,000 birds each year. Weddings, concerts, and other events are held at the gazebo on the newly landscaped park grounds. The park is the permanent home of the Peach Festival and is a lovely natural park area for the townspeople.